†

TEXTS BY MARTIN BARNES AND JOHN GOODALL

# THE ENGLISH CATHEDRAL † PETER MARLOW

MERRELL

LONDON · NEW YORK

6

INTRODUCTION

MARTIN BARNES

12

CATHEDRAL DAYS

PETER MARLOW

16

# THE ENGLISH CATHEDRAL

102

COMMENTARIES

JOHN GOODALL

124

TECHNICAL NOTE

PETER MARLOW

# INTRODUCTION

MARTIN BARNES

There are few experiences more uplifting and humbling than standing in the nave of a cathedral. With the symmetry of columns soaring into arches, and the fine tracery of windows allowing an ethereal light to enter, the effect is like frozen music. These are spaces filled with centuries of human aspiration after the divine; in them, spiritual yearning is made palpable through stone.

Cathedrals also tell of human power, pride, frailty and failings, in the monuments to knights, aristocrats, poets and clergy asking not to be forgotten, and the signs of ecclesiastical reformation in the fragments of paintings that once brightly decorated the walls, or the defaced sculptures of saints. Architectural styles come and go, from the round arches and solid columns of the Norman or Romanesque through the pointed, attenuated Gothic to the cool, mathematical proportions of the Classical, the ornamented swagger of Baroque and the stark cleanliness of Modernism. The majority of English cathedrals are predominantly Gothic, but an accretion of styles can commonly be seen in the same building. Part of the joy of visually reading an English cathedral is in unpicking its divergent architectural heritage, fathoming the puzzle of the dates in its phases of construction and seeing how one style or proportion greets the next, whether in slightly uneasy counterpoint or in harmony. In this way, the building can be witnessed as a preserved monument and also a living and growing organism.

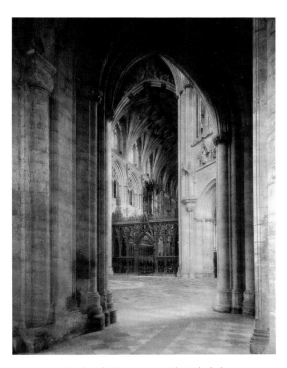

Frederick Henry Evans, *Ely Cathedral*
photogravure, *c.* 1899

In just over three years, Peter Marlow photographed the interior of each of the forty-two Anglican cathedrals in England. The result is not only a magisterial comparative inventory caught in a specific time frame, but also a subtle interpretation of the inner bodies of these awe-inspiring buildings. Although this project began in 2009, the seed of the idea, and the skills to realize it so deftly, began growing for Marlow at the very beginning of his engagement with photography at the age of nineteen.

In 1971, during his first year at university as a student of psychology, Marlow visited Boston, and saw at the Museum of Fine Arts there an exhibition of photographs by Walker Evans (1903–1975), curated by John Szarkowski. Alongside his famous portraits of the rural poor during the Great Depression, Evans's characteristically precise and intelligent

photographic sensibility was often applied to depicting the modern American vernacular: farmhouse interiors, factories, shop signs, roadside warehouses, housing and churches. Evans avoided the overt stylistic gestures of authorship prevalent in fine-art photography of the time. Instead, approached with steady and factual clarity, his subjects are allowed to project their own poetry. Inspired by this encounter with Evans, Marlow purchased a Graflex Speed Graphic camera on his return home, and his career in photography began.

Obtaining a job as a photographer on a cruise liner allowed Marlow to save enough money to spend two months in Haiti, where, on his first foreign project, he photographed the people and places in the black-and-white documentary manner of Evans. As his photographic career took off, he secured commissions from the *Sunday Times Magazine*, as a photojournalist. He joined Sygma, a picture agency with a hard-nosed reputation, and in 1981 was elected to the Magnum Photos cooperative, joining its legendary roster of photojournalists. Marlow travelled widely, covering stories ranging from revolution in the Philippines and Poland to conflict in Zimbabwe, Northern Ireland and Kosovo. Designed to make his pictures stand out on magazine pages, his photographic style became punchy, gritty and angular. The agitation and movement in the images matched the tenor of the often turbulent or violent stories.

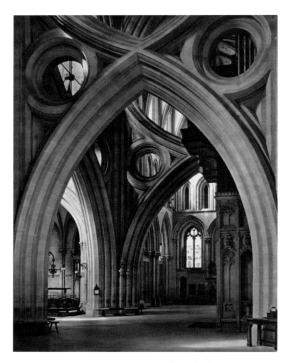

Martin Hürlimann, Wells Cathedral
from *English Cathedrals*, 1950

Despite his skill and success in this genre, however, Marlow was troubled by the environments in which he found himself. He yearned for locations closer to home, and to find a new visual identity that for him signified more than 'just covering the news'. Personal as well as commissioned projects followed, and his approach began to shift. In 1982 he photographed by night the eerie hinterland of London's Isle of Dogs before its redevelopment as a financial district. In 1985 he began what was to become a six-year project, *Liverpool: Looking Out to Sea*, a sometimes tough yet lyrical account of the city and its people. The use of long exposures and the air of silent exactitude in these pictures have re-emerged in Marlow's present photographs of cathedrals. In about 1990 he began to work in colour, and experimented too with medium- and large-format cameras. This necessitated slowing down, moving away from the photojournalistic vortex of action and instead turning an inquisitive

eye on peripheral scenes. This sensitive and increasingly quiet engagement with places, allowing the environment to yield its own picture, became Marlow's hallmark.

The impetus to start photographing cathedrals was the result of a commission from the Royal Mail in 2007 for use on a set of commemorative stamps.[1] The guidelines set out by the Mail's Stamp Committee required black-and-white images of the interiors of seven cathedrals, looking east. The brief dictated a comparative, classificatory approach. Once the commission was complete, however, Marlow was inspired to continue in a similar vein from his own interest, and by the end of 2010 he had photographed thirty-two cathedrals. The taxonomic, comparative idea remained, but the images were now in colour. Marlow applied to the Dean and Chapter of each cathedral to gain permission to enter in the early hours of the morning. In nearly all cases he was allowed to turn lights off, leaving the interiors to be illuminated naturally, just after sunrise. The effect of natural light modulated the spaces and brought out the luminosity of the stone, and – especially when Marlow was photographing west to east (as in most cases) – the gathering daylight emerged from behind the altar and highlighted the ceiling of the choir.

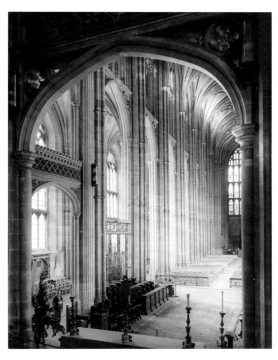

Edwin Smith, *Canterbury Cathedral*, 1968

This method of working required the images to be made between late spring and early November. Marlow adopted a kind of ritual, rising as early as 3 am to drive to each cathedral and begin working at 6. In these precious hours, a short window of opportunity, he watched the cathedral interior emerge from darkness and come to life. Few of us are privileged to witness the interior of a cathedral by being left alone in the magnitude of its spaces at dawn. Marlow's photographs make this personal, contemplative encounter powerfully accessible: they pass the magic on to us.

Photographers of English cathedrals before Marlow have trodden a path between architectural illustration and emotive expression. Of them all, Frederick Henry Evans (1853–1943) set the benchmark. During the years around the turn of the twentieth century he would spend weeks at a cathedral observing the light and requesting, where necessary, the removal of unsightly modern chairs or light fittings.[2] His abhorrence of what he saw as insensitive later additions to the architecture reflected William Morris's preservationist ideas

on the restoration of ancient buildings. It also mirrored Evans's own views on retouching in photography, which to him was the equivalent of damaging a good building by making alterations or additions. (Marlow is similarly against retouching, as he explains in his technical note on pp. 124–27.) Evans gave evocative titles to his cathedral studies, such as *A Sea of Steps*, *The Strength of the Normans* and *In Sure and Certain Hope*, revealing his desire to produce artworks that are more than a transcript of reality. 'Try for a record of emotion rather than a piece of topography', he wrote. 'Wait till the building makes you feel intensely, in some special part of it or other; then try and analyse what gives you that feeling … and then see what your camera can do towards reproducing that effect.'[3]

During the same period, photographs were used for the first time to illustrate architectural guidebooks on English cathedrals. Francis Bond's *English Cathedrals Illustrated* was published in 1899 and ran into several editions. Yet the small scale and practical context of the reproductions do not draw attention to the skill or art of the various photographers, which included Francis Frith & Co. Such has been the case for the majority of books produced as guides on the subject since. However, the work of three notable photographers, Edwin Smith (1912–1971), Anthony Frank Kersting (1916–2008) and Martin Hürlimann (1897–1984), stands out. Smith's self-effacing but exquisitely produced photographs are credited in many of the cathedral and other architectural books of the twentieth century. Kersting supplied illus-

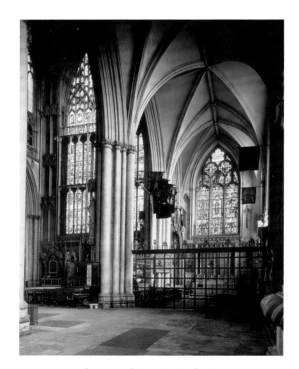

Anthony Frank Kersting, York Minster
from *English Cathedrals in Colour*, 1960

trations for Nikolaus Pevsner's *Buildings of England* series and for *English Cathedrals in Colour* (1960). Hürlimann was particularly prolific on the subject, as both writer and photographer, with his large-scale and finely printed *English Cathedrals* (1950).[4]

However, in the rigorous parameters and timescale of its approach, and not least the extremely high quality of its colour images, Marlow's project differs from all those listed above, and indeed from any published to date. He is not concerned with illustrating the exterior setting or the standard noteworthy architectural features. This liberates him from the selective description of specifics. In fact, after so long spent needing to know the background while covering stories as a journalist, Marlow speaks of the freedom of not

feeling fully qualified in the history of his subject. But through his conceptual approach rather than focused selection, certain unusual and alternative specifics do stand out against the background of his even-handed portrayal: look, for example, at the golden crown light-fitting that hovers at Hereford or the curiously alien form that seems to descend from the lantern tower at Sheffield.

While Marlow's taxonomic approach lends itself to architectural comparison, this is not the purpose of the images. They may be considered instead in the same light as the elegantly spare images of the Bechers, Bernd (1931–2007) and Hilla (born 1934), who investigated the relationship between form and function, especially in vernacular and industrial architecture. Many of their photographs show a particular type of building repeated in a grid (gasometers, grain lifts, water towers or blast furnaces). Their work has been called at once topological documentation, typological study and conceptual art. The individual places are important, but it is their cumulative effect as variations on a universal theme that is transformative. In Marlow's as in the Bechers' work, the almost hypnotic repetition of a standard viewpoint directed towards a single building type suggests the abstract mapping of form within space. It is like being privy to the projections and patterns of the architect's imagination. While on one level we 'read' the cavernous cathedrals receding in single-point perspective, as we turn the pages we also become increasingly aware of the tracery of lines on the two-dimensional plane of the paper.

As with Walker Evans, who first inspired him, Marlow in his cathedral photographs takes a step back from his subjects to allow them the room to speak for themselves. The images eschew an overt signature style for something less invested with the artist's ego, and more open. As a result, Marlow retreats from the suggestion that his project can be seen as the equivalent of a pilgrimage in photography. His considerable efforts to make the images should fade into the background of that suggestive meeting point between image and subject. When immersed in Marlow's photographs we are metaphorically in some kind of contemplative enclosure, if not a sanctuary: one that confronts us with our own sense of being. The forms captured here are simultaneously concrete and abstract: containers of history, light and, above all, space. Despite of, and in parallel with, the undeniable structure of the architectural edifice, Marlow captures the intangible essence of all form that is generated by creative force: the enduring mystery of space within space.

1. The set of stamps, 'British Cathedrals', was issued on 13 May 2008, and celebrates the 300th anniversary of the completion of St Paul's Cathedral. The stamps, designed by Howard Brown, show Lichfield, Belfast, Gloucester, St David's, Westminster, St Magnus's and St Paul's.
2. Beaumont Newhall, *Frederick H. Evans*, Millerton, NY (Aperture), 1973, p. 12.
3. Quoted in *Amateur Photographer* 8, no. 1019, 12 May 1904, p. 372.
4. See Nikolaus Pevsner and Priscilla Metcalf, *The Cathedrals of England*, Hammondsworth and New York (Viking) 1985 (with many images by Kersting); Patrick Cormack, *English Cathedrals*, London (Artus) 1984 (with illustrations by Smith and Kersting); Martin Hürlimann, *English Cathedrals*, London (Thames & Hudson) 1950; A.F. Kersting, *English Cathedrals in Colour: A Collection of Colour Photographs*, London (Batsford) 1960; and Alec Clifton-Taylor, *The Cathedrals of England*, London (Thames & Hudson) 1967.

# CATHEDRAL DAYS

PETER MARLOW

How many times in a year do you wake up excited about what is going to happen that day? I felt that way on most of my 'cathedral days'. Driving through the night, sometimes, to arrive just before dawn, I had no need for a map: these English architectural masterworks are easy to find, towering above their cities as many of them have done for more than 900 years.

On a still summer evening more than forty years ago, next to a ruined watermill on the banks of the River Avon in Gloucestershire, I was trying to work out how to use the Graflex 5 × 4 Speed Graphic camera I had just bought from *Exchange & Mart*, the eBay of the era. I had this wonderful object but no subject, and – frustrated by the dull routine of studying for an engineering degree – I was desperate to be a photographer. I planned to travel the country photographing English cathedrals, then to travel the world photographing wars. Should I continue with my degree or go to Vietnam? It never quite happened that way; I changed to psychology and completed my degree. But I did become a photographer.

In the 1980s, after years spent working as a photojournalist in over eighty countries, I felt a strong need to explore my own country. Strangely enough, in 2007 – more than twenty-five years later – I won a commission to photograph eight British cathedrals for the Royal Mail. Subsequently, with *English Cathedrals* (1989) by Edwin Smith and Olive Cook as my guide and a pack of 'Anglican Cathedrals of England' Top Trumps, I set out to photograph all forty-two.

I loaded up my car with a stepladder, three camera boxes and a very large tripod, swathing the ladder in a blue padded sleeping bag, like a body, to muffle the annoying rattle of the aluminium. I began by photographing the aesthetic highlights of each building, but the images seemed to merge with one another. In order to differentiate each place I needed to find a more rigorous and systematic approach, and so I adopted the simple strategy of photographing the naves looking along the central axis. There were other decisions to be made: whether to photograph from east or west, for example. I always tried both, and often entered during darkness, setting up my equipment in front of the west door and waiting for the sun to come up behind the altar. The viewpoint added depth to the visual experience of the building, and the discipline of this strict approach was liberating as I simply looked, allowing the power of the place to unfold in the dark.

The sense of mystery was absent, however. I found it by accident at Rochester just before dawn. When I entered, the lights were all turned off and the huge, silent space seemed locked in time, as if it were there just for me. In the half-darkness, the very air was tangible. I knew then that this was what I needed to discover in all the cathedrals. It was not easy to arrange to have the lights turned off, but I soon realized that it was essential, allowing the buildings to come quietly to life in the tentative morning light. When the lights finally went back on, as services began and visitors and school groups started to arrive, the magic evaporated at the click of a switch.

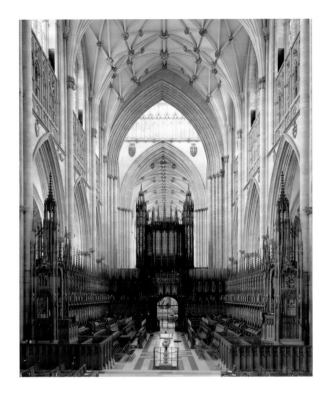
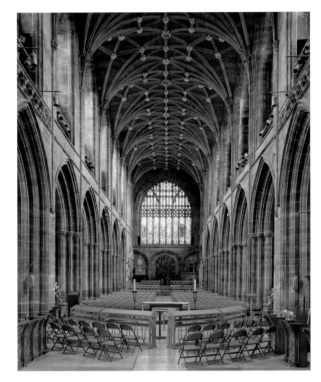
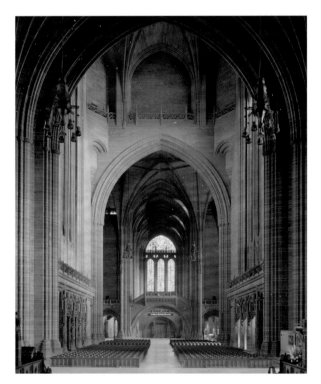

Clockwise from top left: York, Chester (both August 2011), Peterborough (May 2010) and Liverpool (September 2011). These views are taken in the opposite direction to those featured in the main part of this book.

At York Minster, which has its own police force, the constable showed me the light switches in a small wooden cupboard hidden behind the pulpit in the south transept, and left me to it in the dark at 5.30 am. I became expert at finding lighting controls. Chester had one light in the crossing that could not be turned off: it had been on for fifteen years and no one had ever found the switch. At 8 am on the dot the cleaners in their flowery housecoats turned on all the lights despite my pleading; I had taken only one shot and left wanting more.

In Exeter at 6 am there was a man praying halfway down the right-hand side of the nave, and I waited four and a half hours for him to leave. There, too, I photographed the organ as a gift for the retiring organist. In Coventry I was invited to join the dean for Morning Prayer. At Canterbury I got into trouble for creeping in early without permission, in my stocking feet to avoid making any noise. At Ripon a coachload of Spanish tourists arrived every time I was ready to photograph (I finally got the photo at about one in the afternoon, when they had gone for lunch). At Wells I agreed to photograph the triforium gargoyles for an exhibition in the visitor centre. In Carlisle I could not find the nave: Oliver Cromwell had knocked it down in 1649. In Gloucester, early one July morning, I heard the faint sound of the King's School choir drifting through the exquisite fourteenth-century cloisters. There were two men with rifles shooting pigeons inside Peterborough. In Coventry, the light on the Graham Sutherland *Christ in Glory* tapestry could not be turned off, as light always has to shine on Jesus.

Air rifles or the Mappa Mundi: the memories of peripheral things remain as vivid as the historical highlights of each place. I did plenty of research before each visit, and once I felt I had completed the photography, I would spend time sitting in the nave, absorbing the power of a place where for centuries people had experienced the energy, fear and balm of religion. Everything about these places has already been said, but they have not all been 'experienced'.

Early in the morning, with the whole day ahead, working alone in these vast, calming spaces with their supreme expression of everything English, I often felt a paradoxical sense of panic. It reminded me of not knowing where I should be during a quickly unfolding news story. The light changed fast as a big cloud, unseen, passed in front of the sun; a verger turned a light back on; I forgot to remove the darkslide from my Sinar camera; it was too dim to focus; and the battery ran out on the phone I used as a timer for the long exposures. What I thought was going to be incredibly simple became intricate, complicated and utterly absorbing. The journey was memorable and wonderfully hypnotic, a kind of reflective pilgrimage. My cathedral days involved hours of driving and thinking, with my reference Polaroids drying in the sun on the dashboard.

England passed by.

# THE ENGLISH CATHEDRAL

†

BIRMINGHAM **18** 103

BLACKBURN **20** 103

BRADFORD **22** 104

BRISTOL **24** 104

BURY ST EDMUNDS **26** 105

CANTERBURY **28** 105

CARLISLE **30** 106

CHELMSFORD **32** 106

CHESTER **34** 107

CHICHESTER **36** 107

COVENTRY **38** 108

DERBY **40** 108

DURHAM **42** 109

ELY **44** 109

EXETER **46** 110

GLOUCESTER **48** 110

GUILDFORD **50** 111

HEREFORD **52** 111

LEICESTER **54** 112

LICHFIELD **56** 112

LINCOLN **58** 113

LIVERPOOL **60** 113

MANCHESTER **62** 114

NEWCASTLE **64** 114

NORWICH **66** 115

OXFORD **68** 115

PETERBOROUGH **70** 116

PORTSMOUTH **72** 116

RIPON **74** 117

ROCHESTER **76** 117

ST ALBANS **78** 118

ST PAUL'S, LONDON **80** 118

SALISBURY **82** 119

SHEFFIELD **84** 119

SOUTHWARK **86** 120

SOUTHWELL **88** 120

TRURO **90** 121

WAKEFIELD **92** 121

WELLS **94** 122

WINCHESTER **96** 122

WORCESTER **98** 123

YORK **100** 123

†

Page numbers in **bold** indicate the main photograph;
roman page numbers refer to the commentary.

BIRMINGHAM

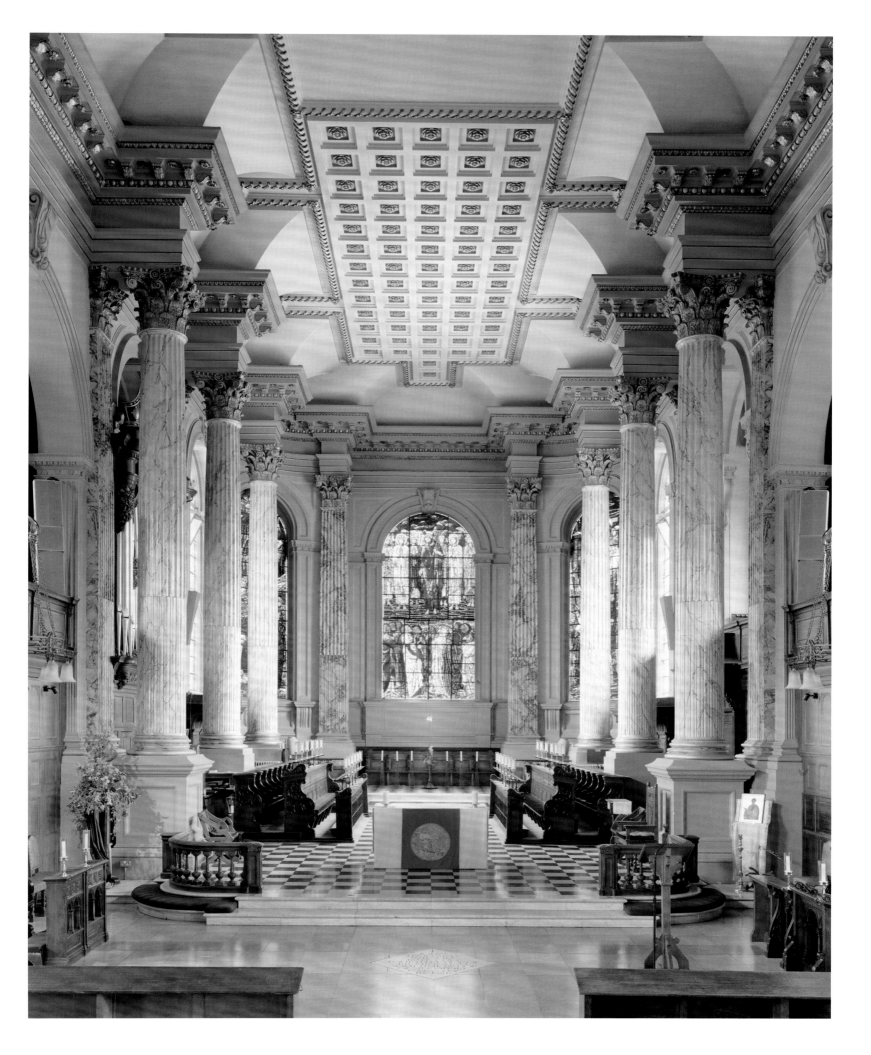

BLACKBURN

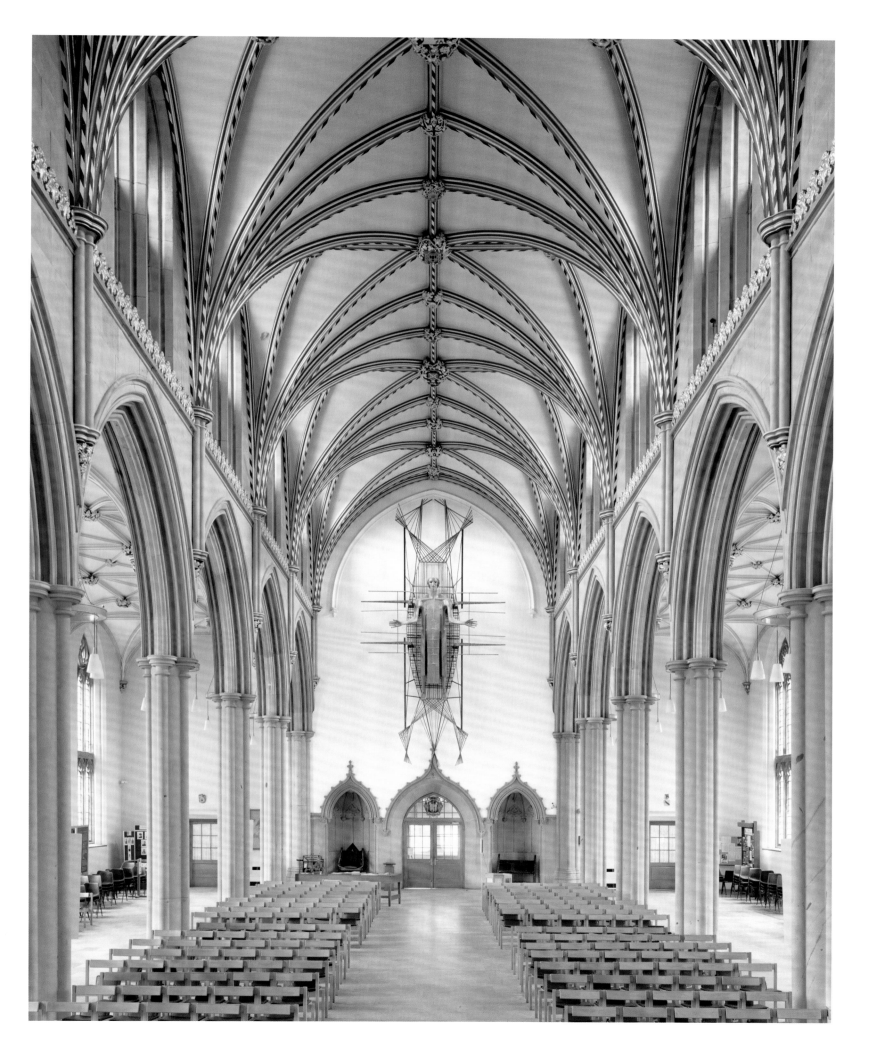

BRADFORD

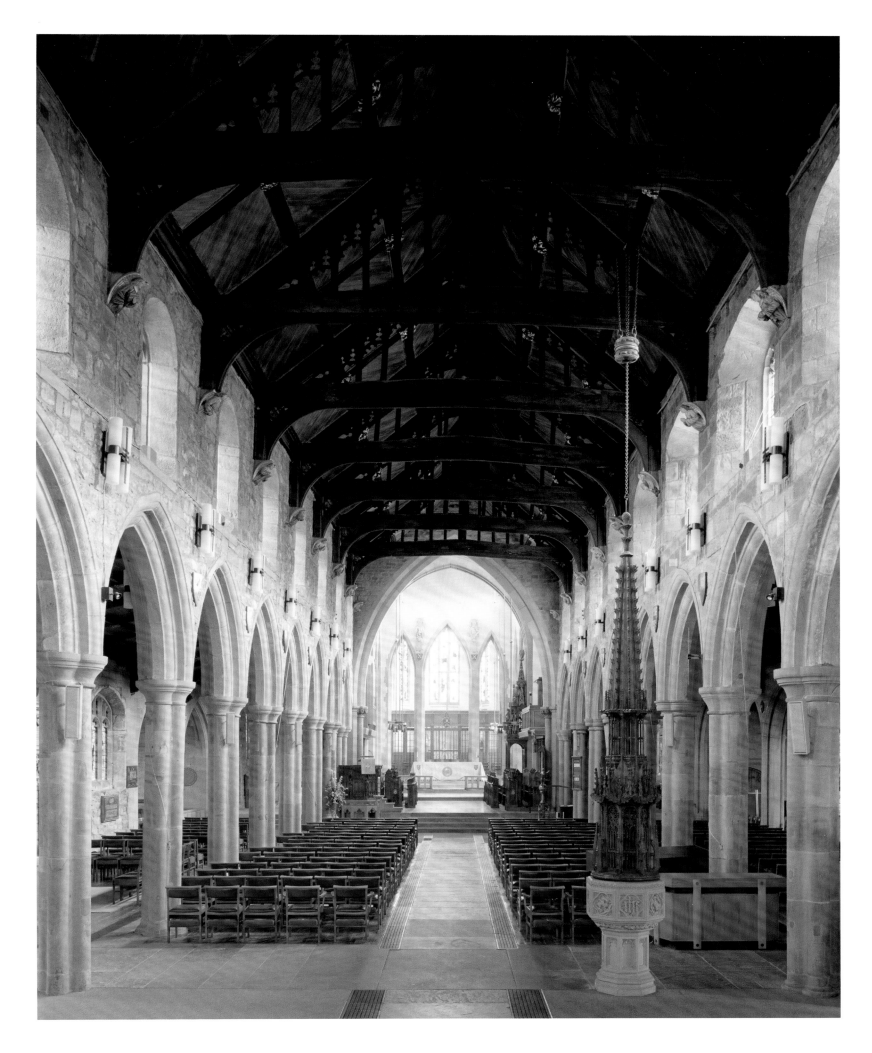

BRISTOL

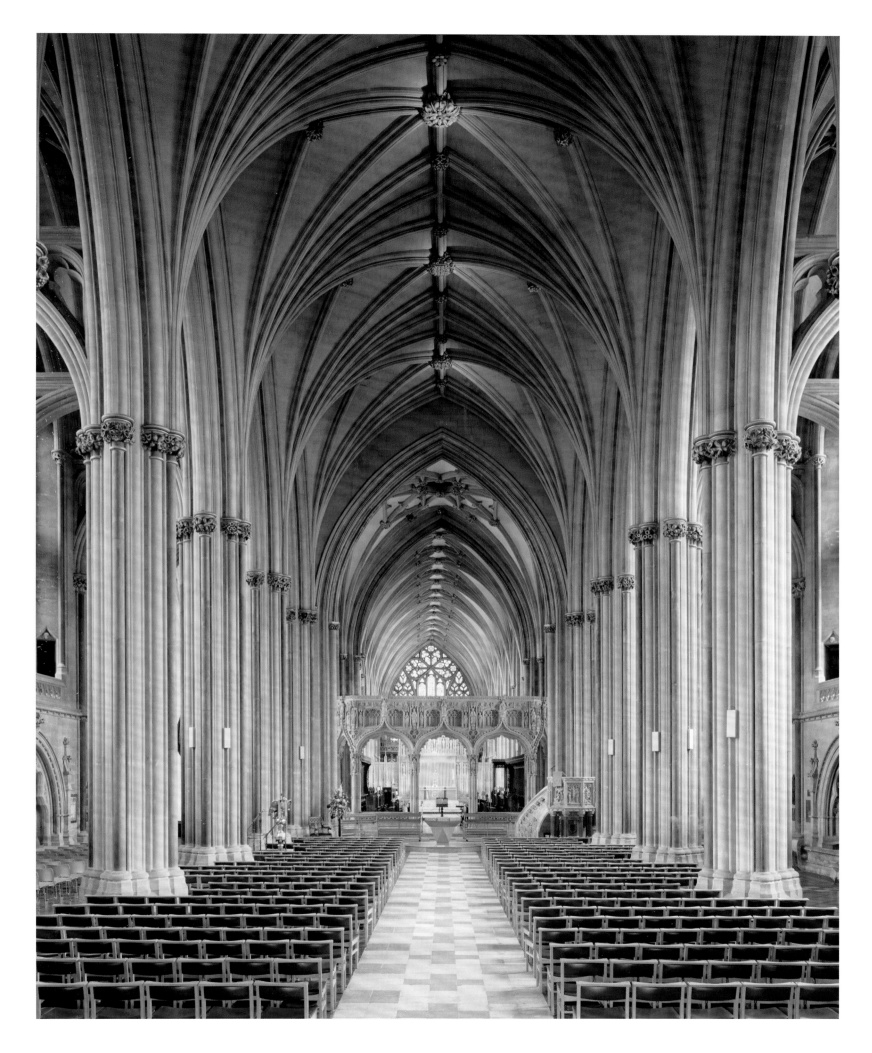

BURY ST EDMUNDS

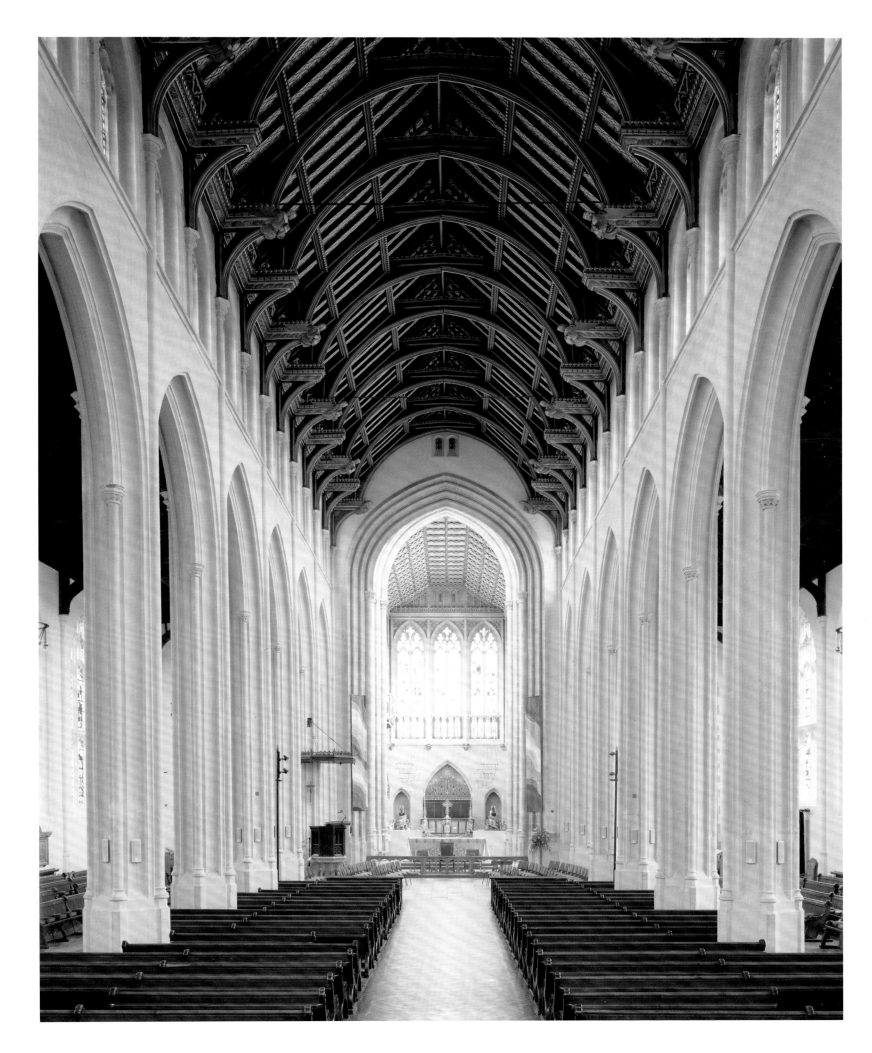

CANTERBURY

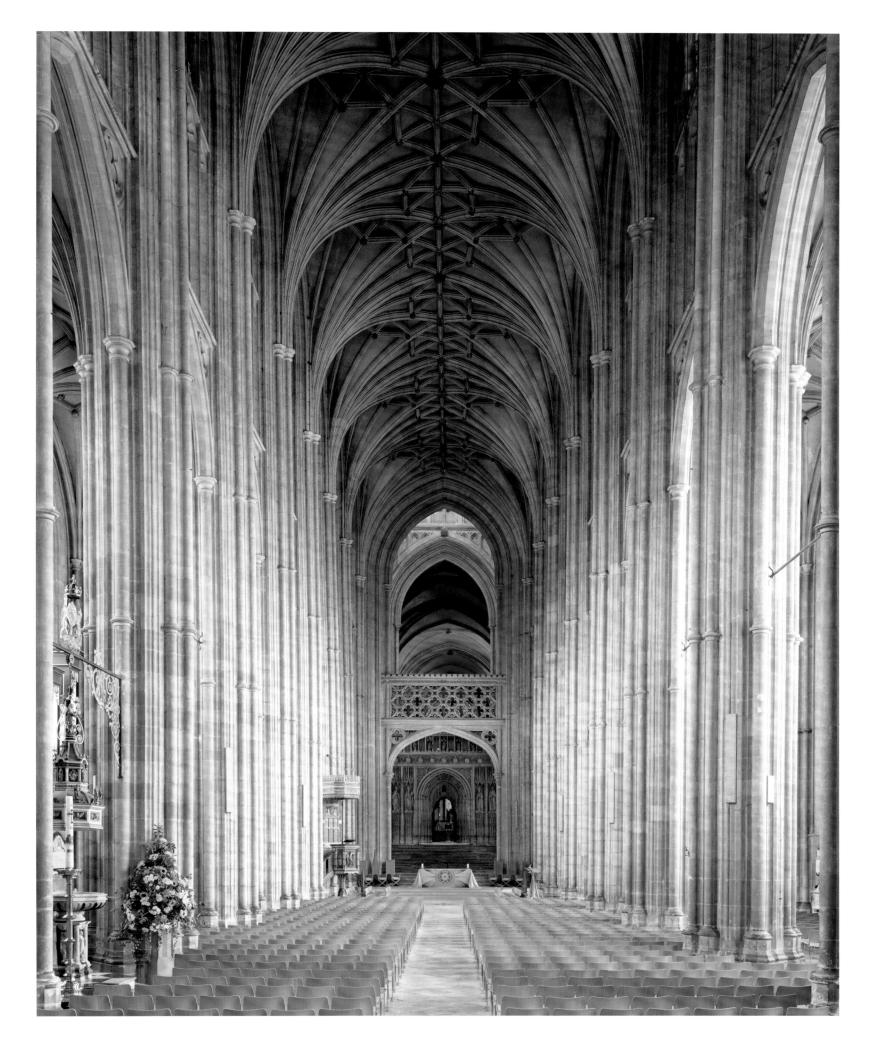

CARLISLE

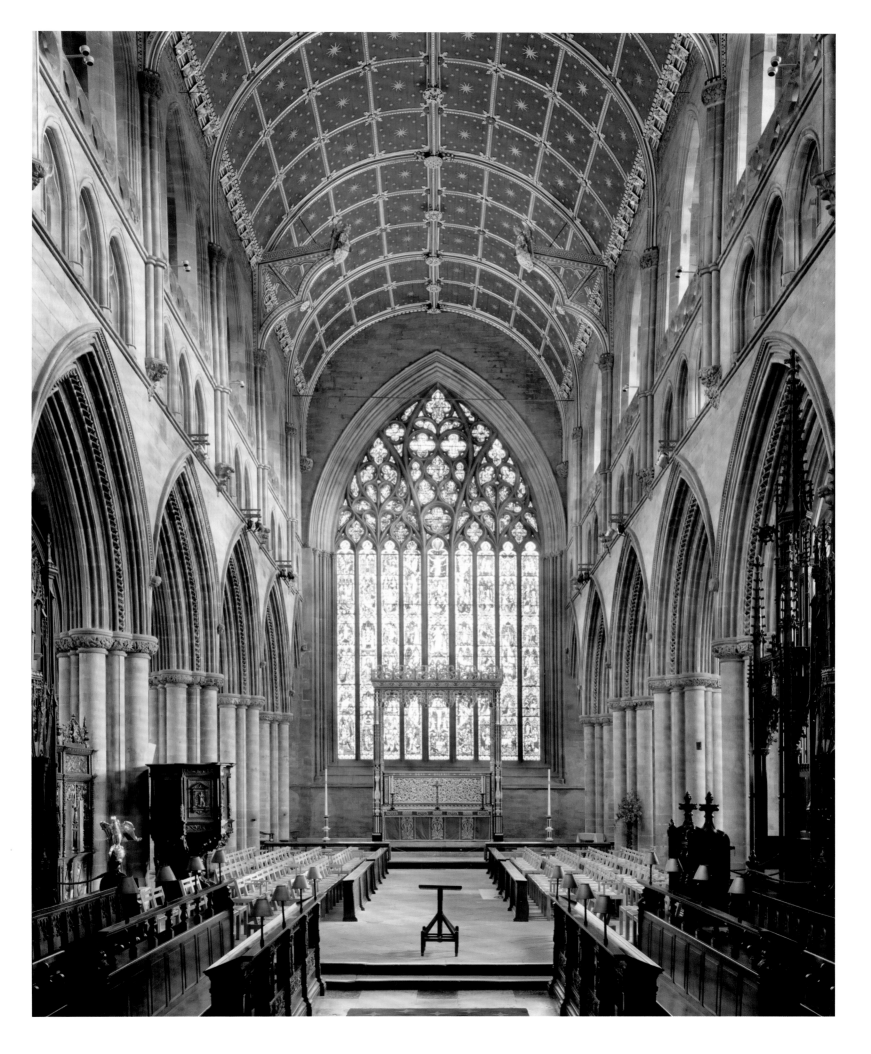

CHELMSFORD

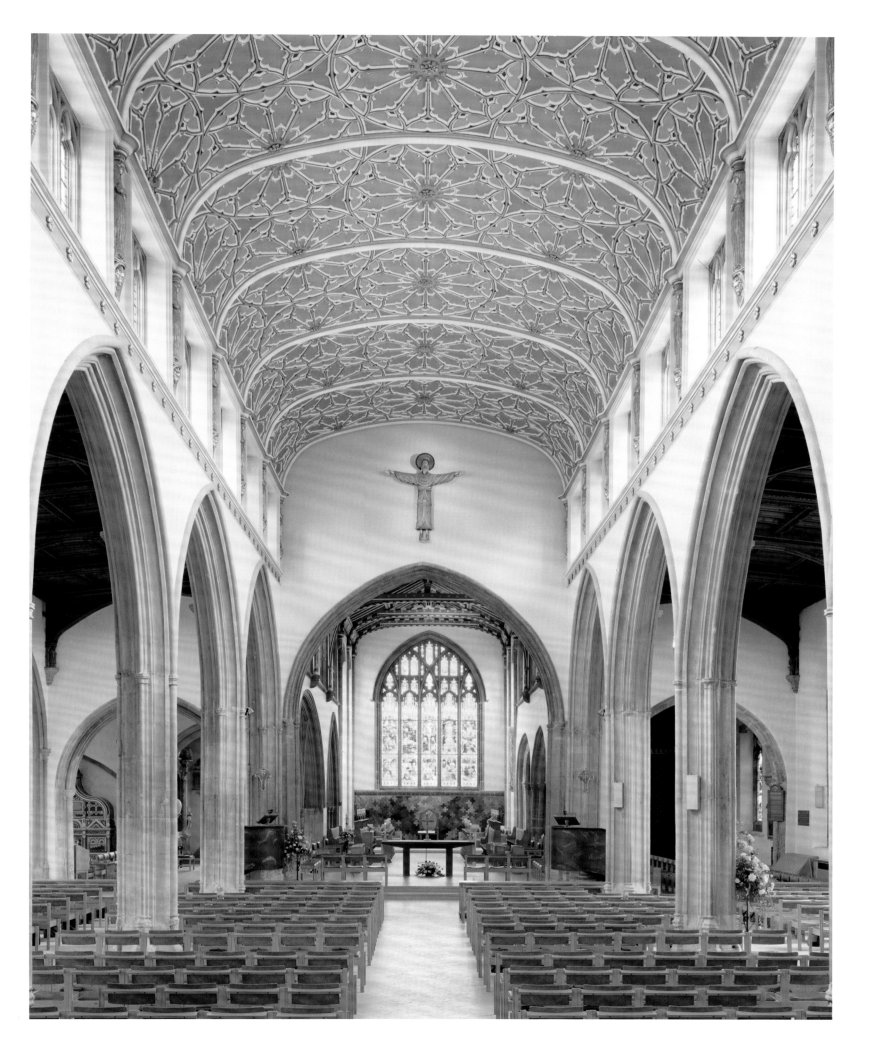

CHESTER

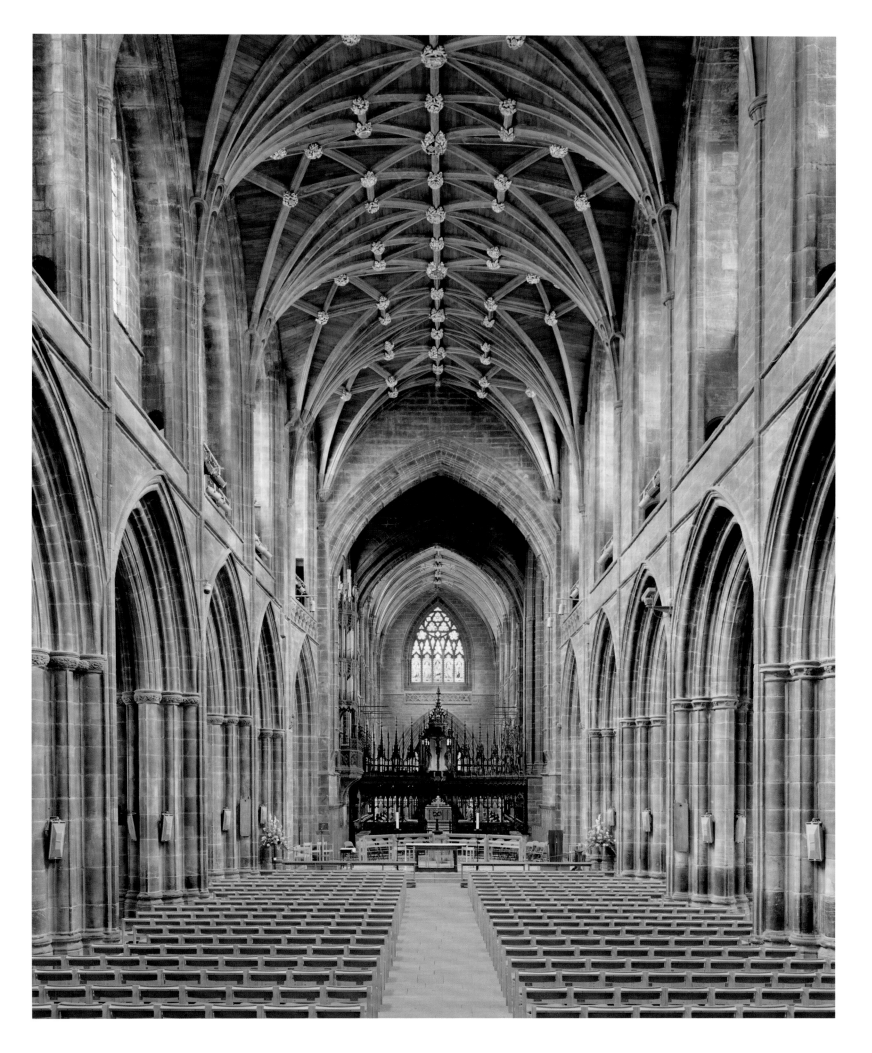

CHICHESTER

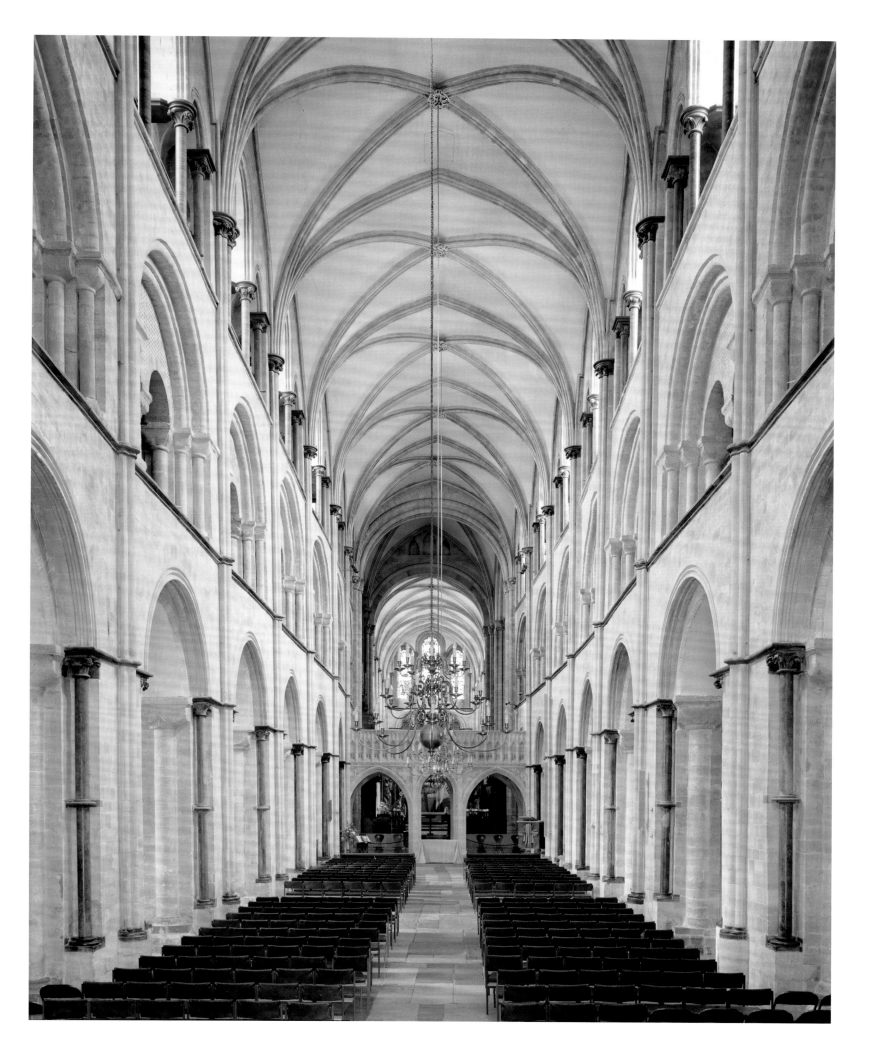

COVENTRY

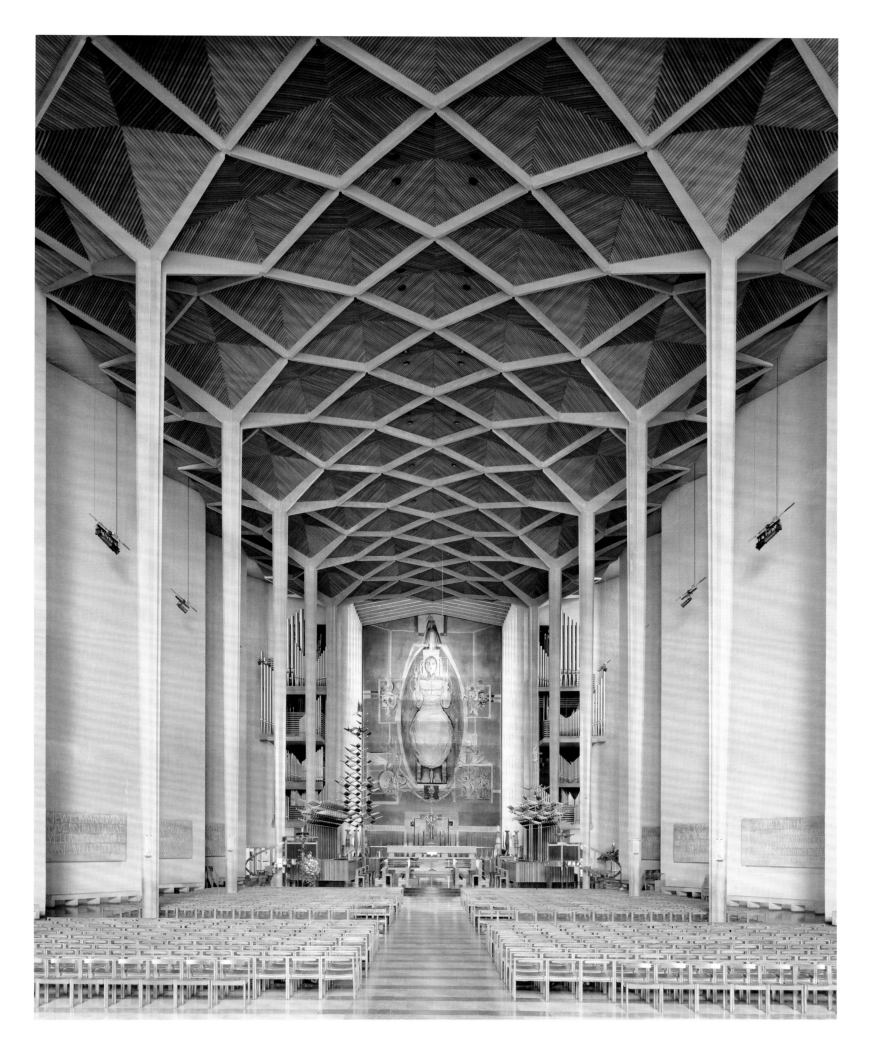

DERBY

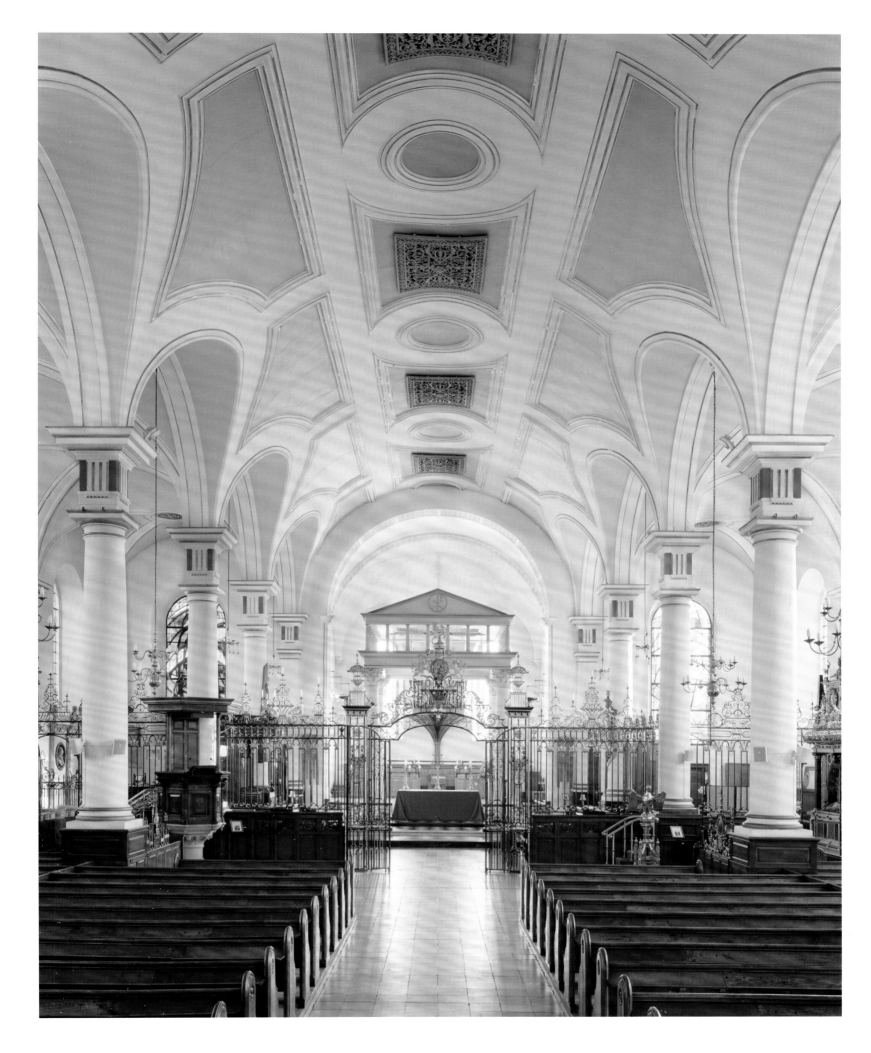

DURHAM

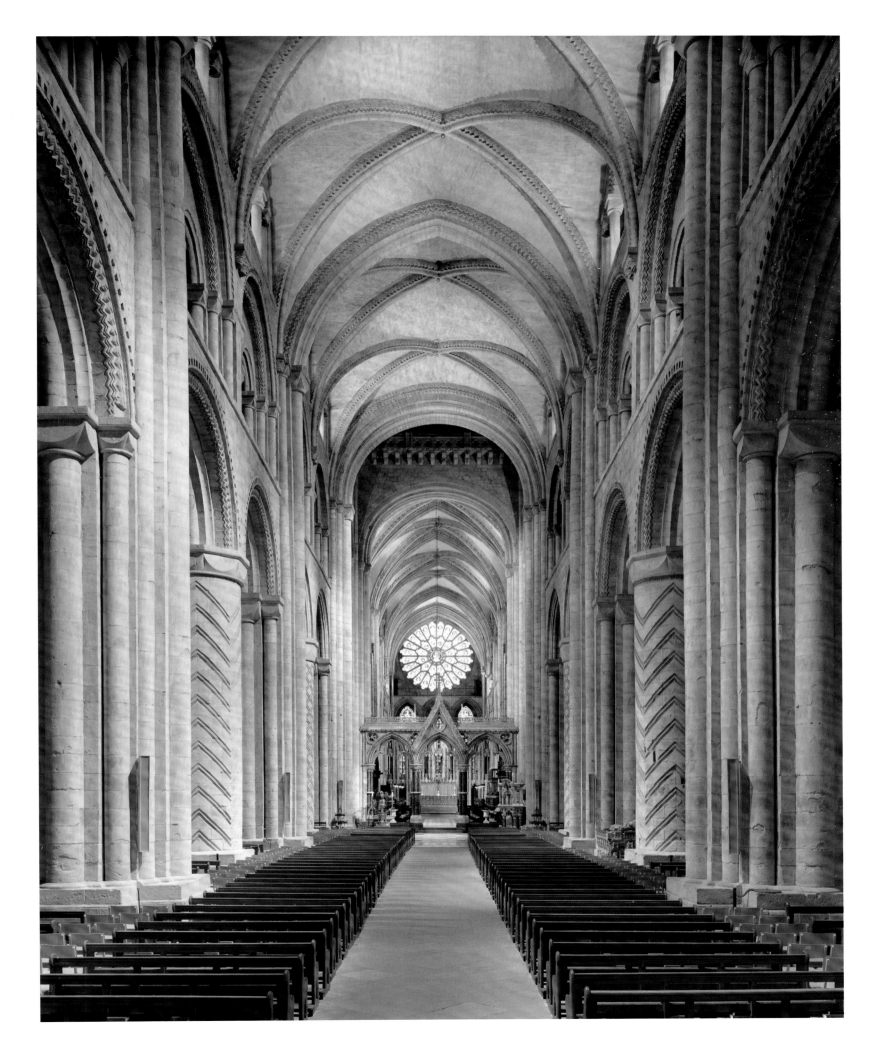

ELY

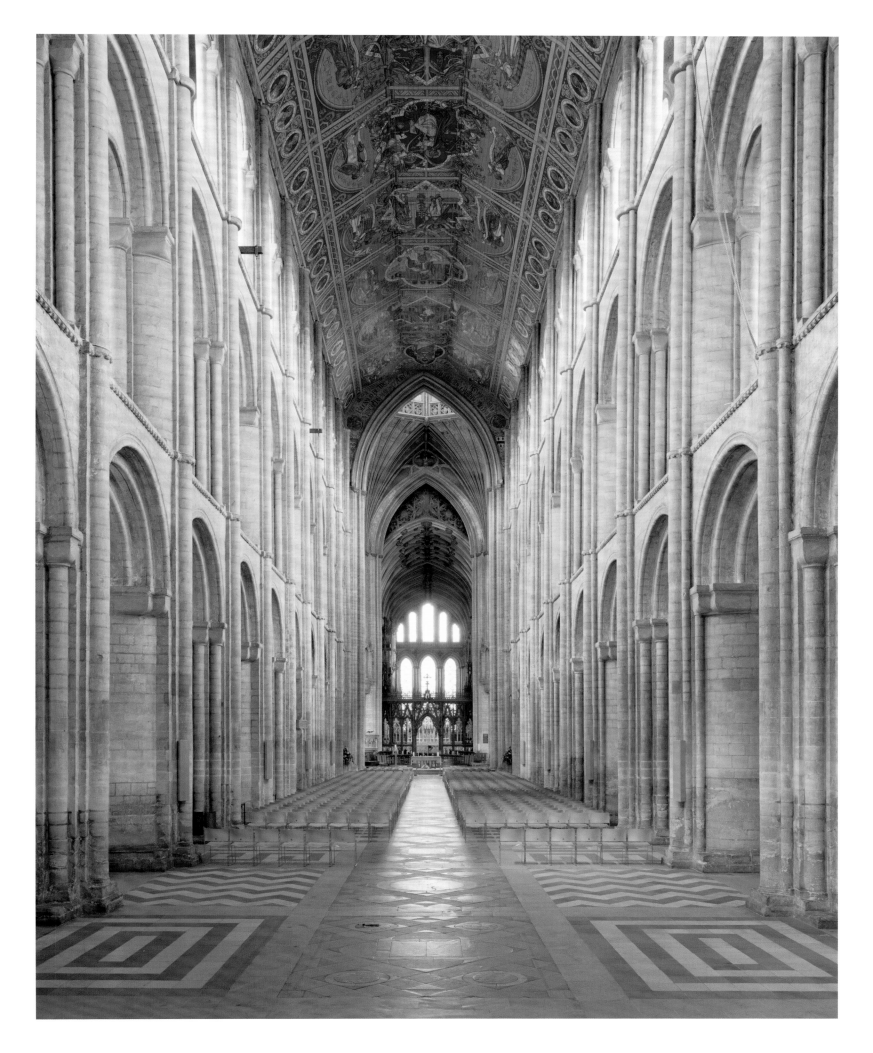

EXETER

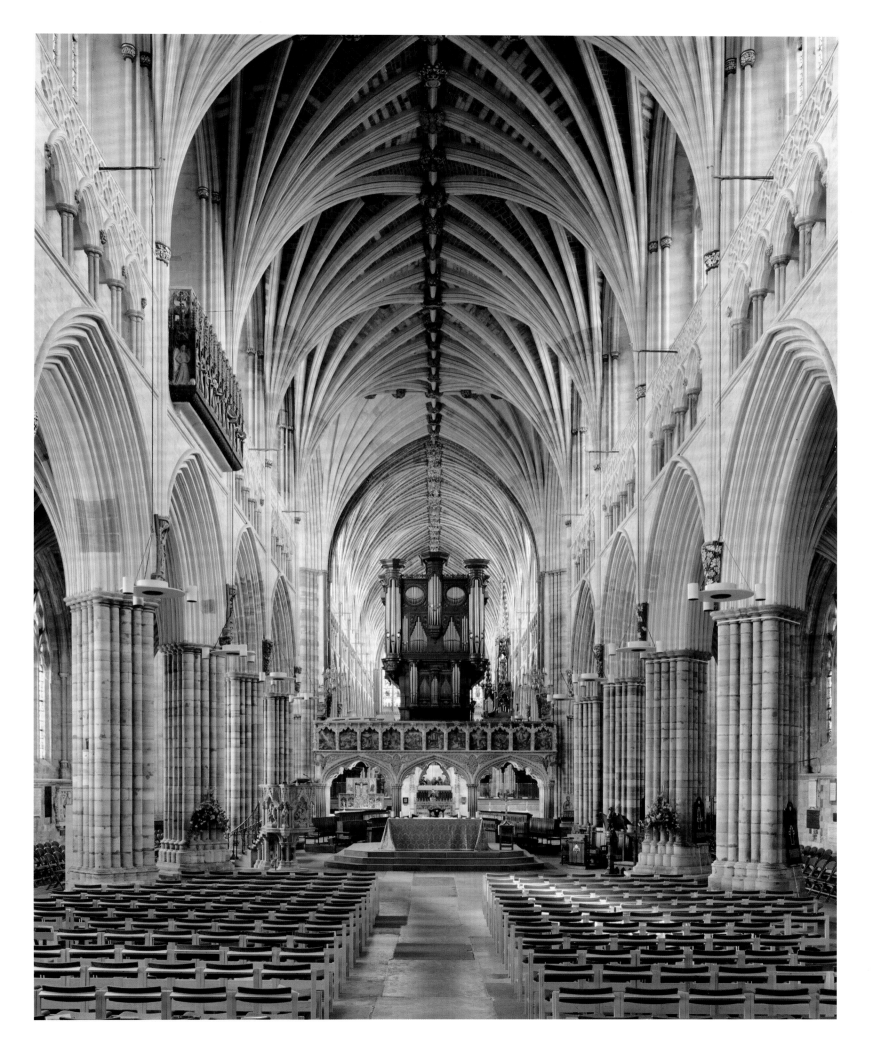

GLOUCESTER

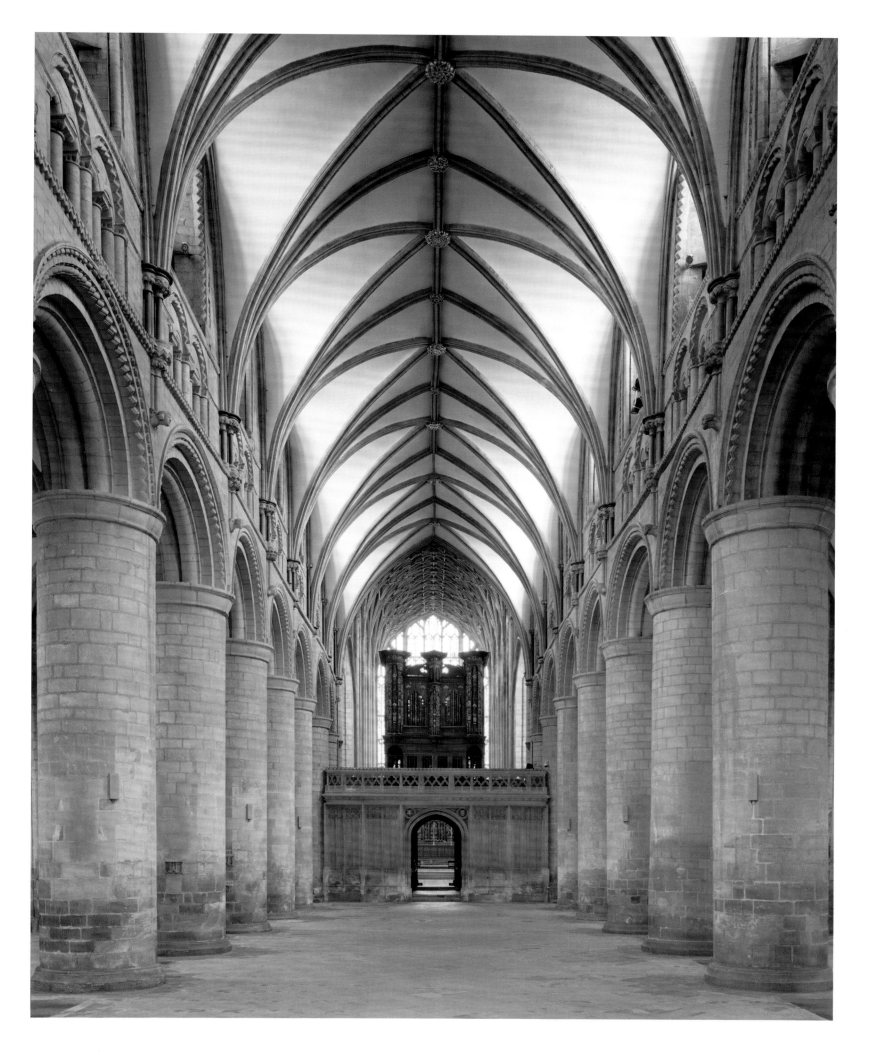

GUILDFORD

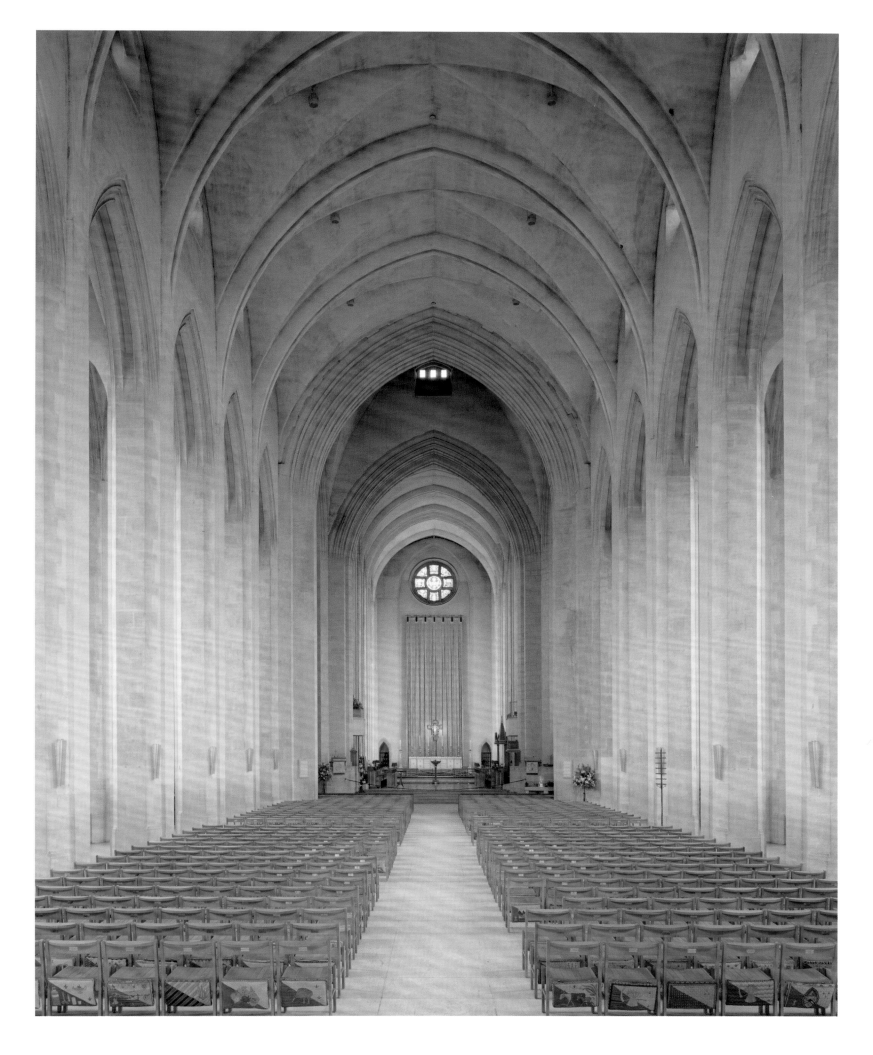

HEREFORD

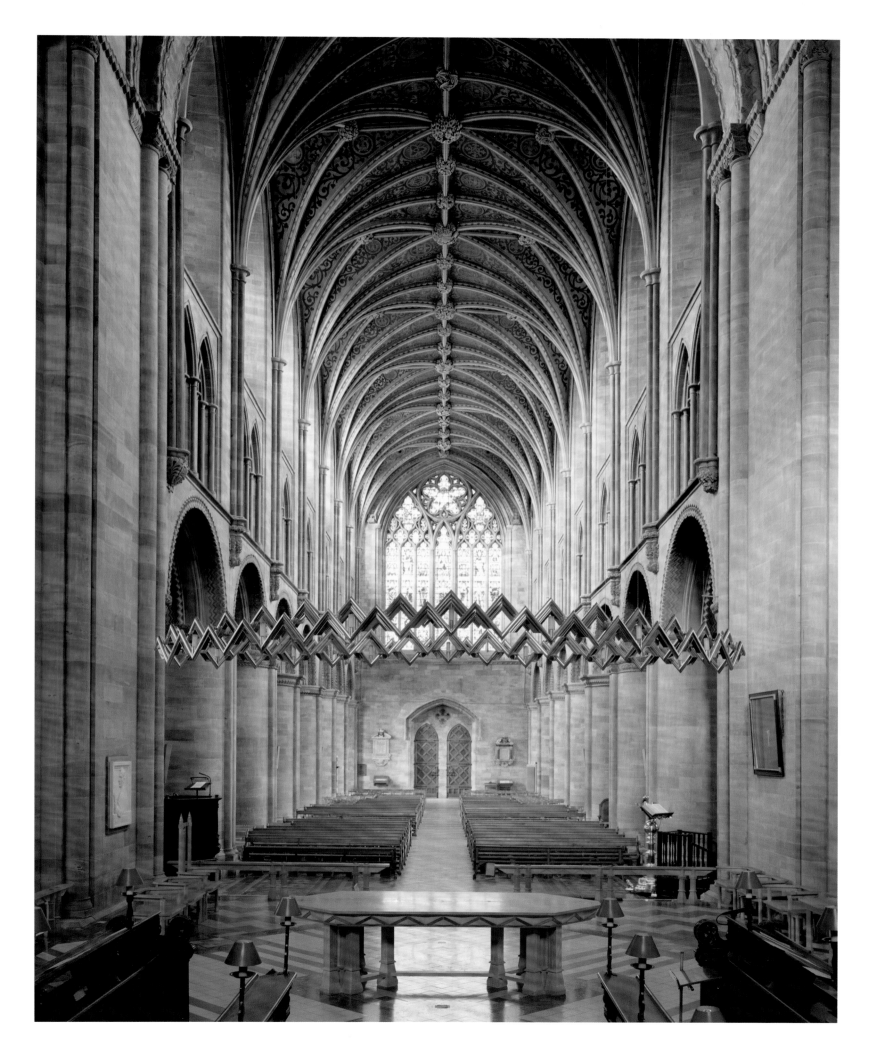

LEICESTER

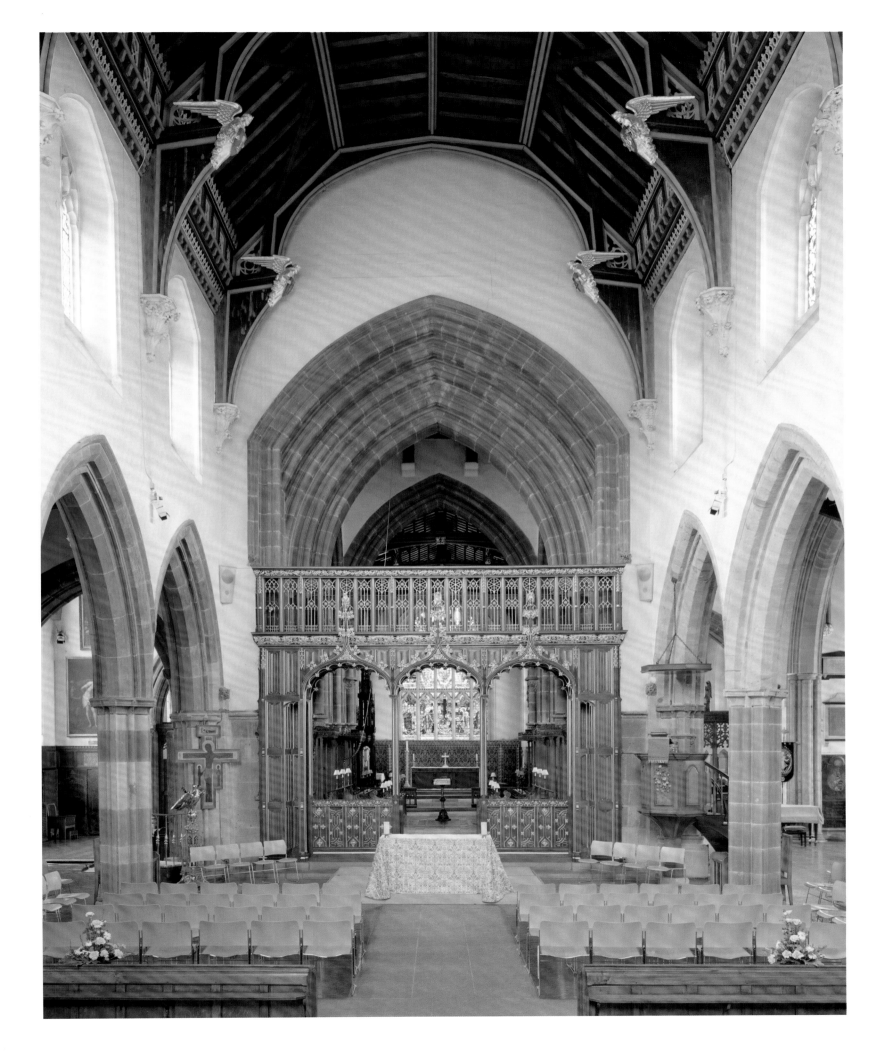

LICHFIELD

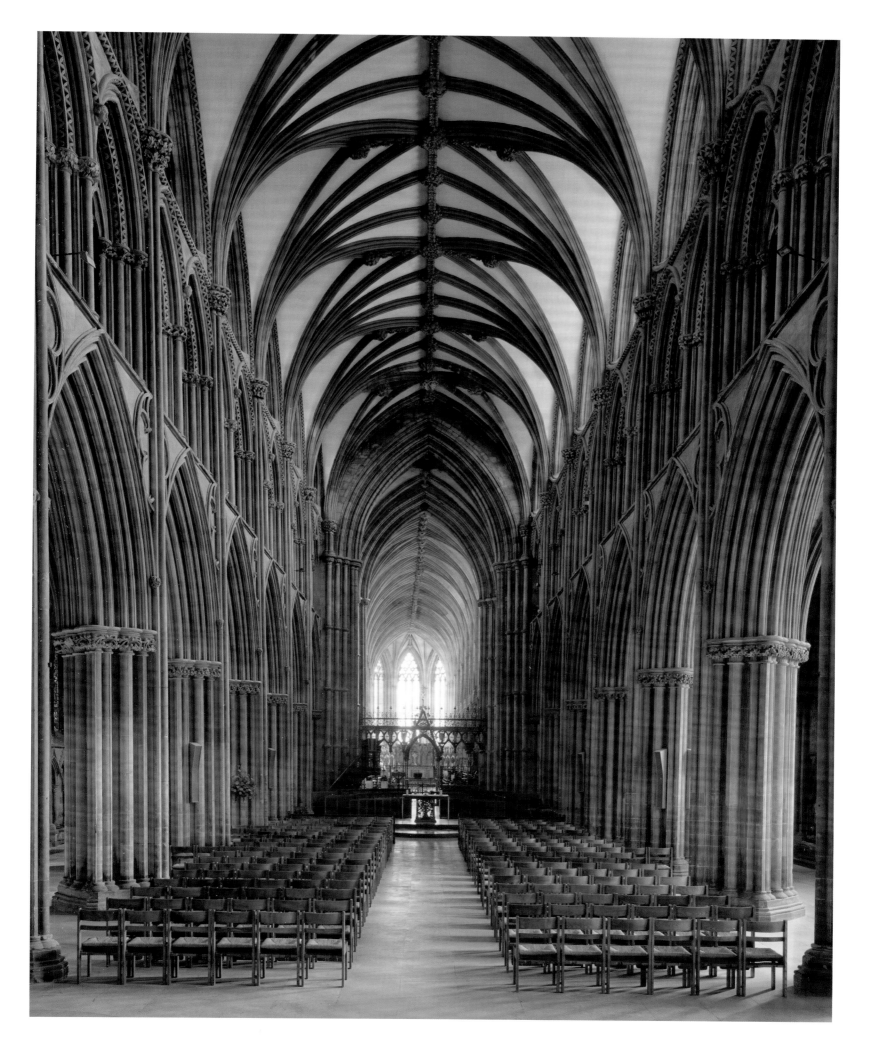

LINCOLN

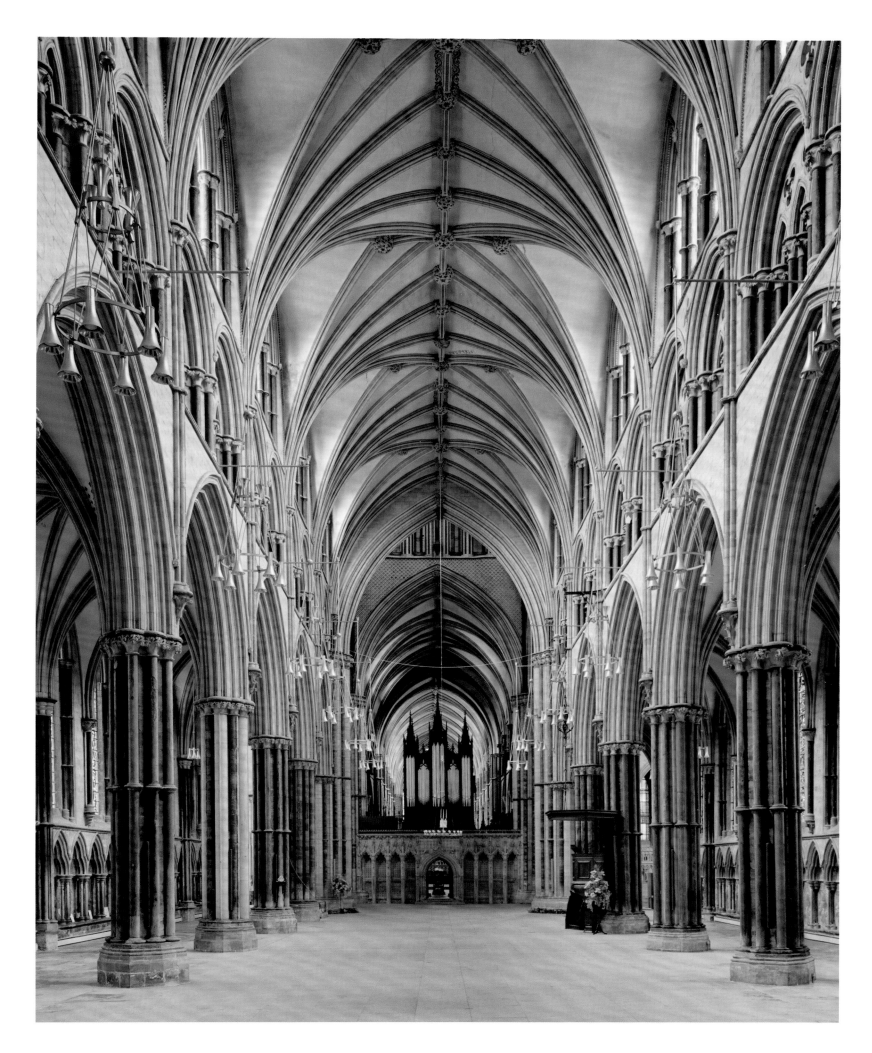

LIVERPOOL

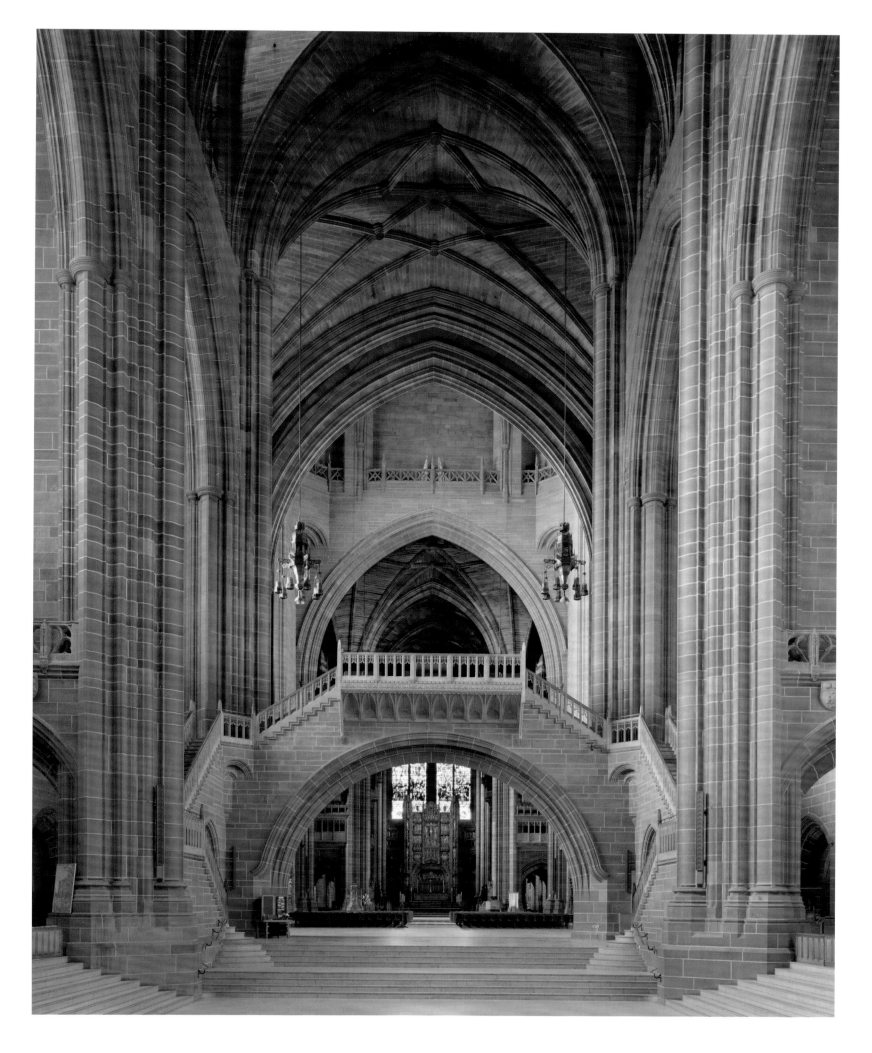

MANCHESTER

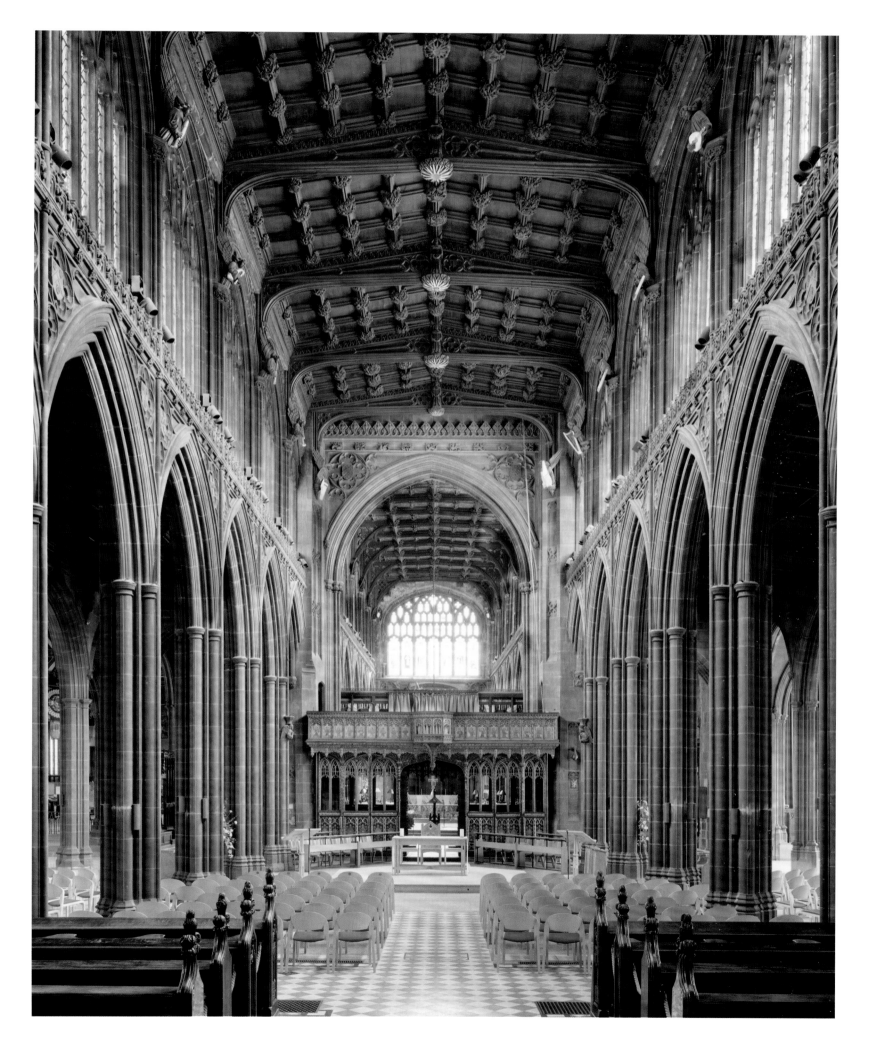

NEWCASTLE

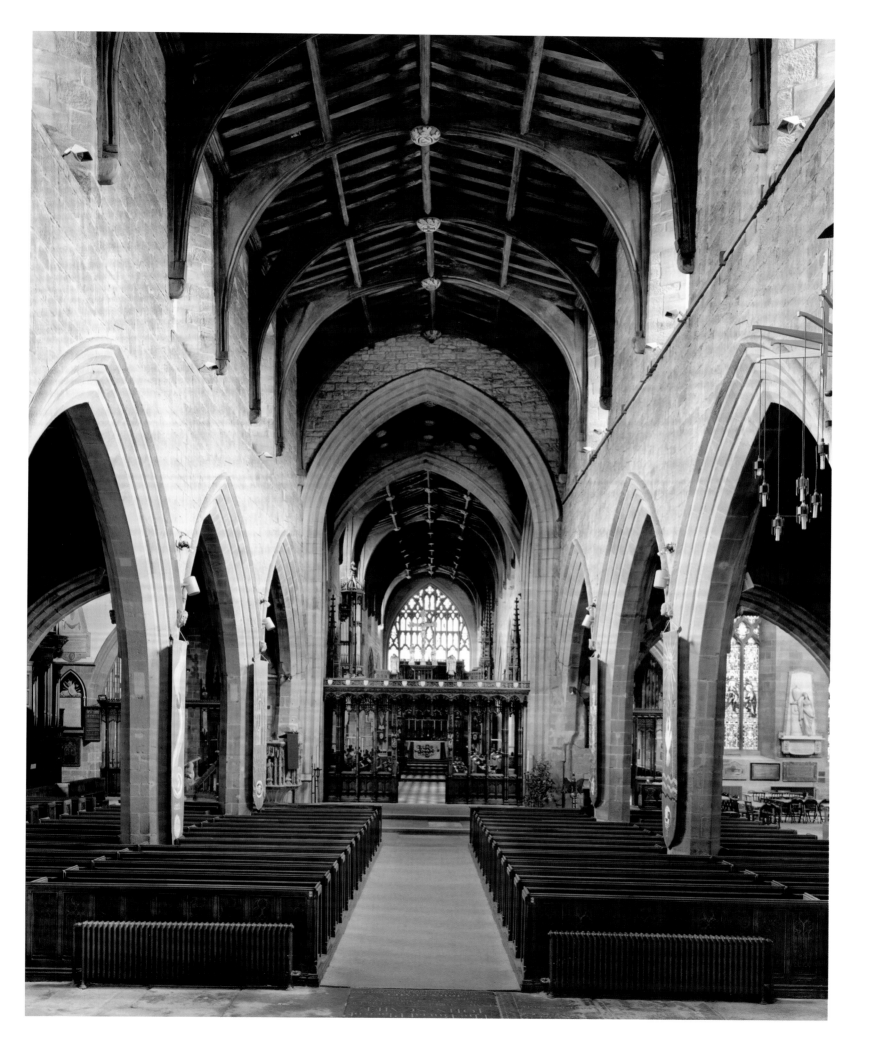

NORWICH

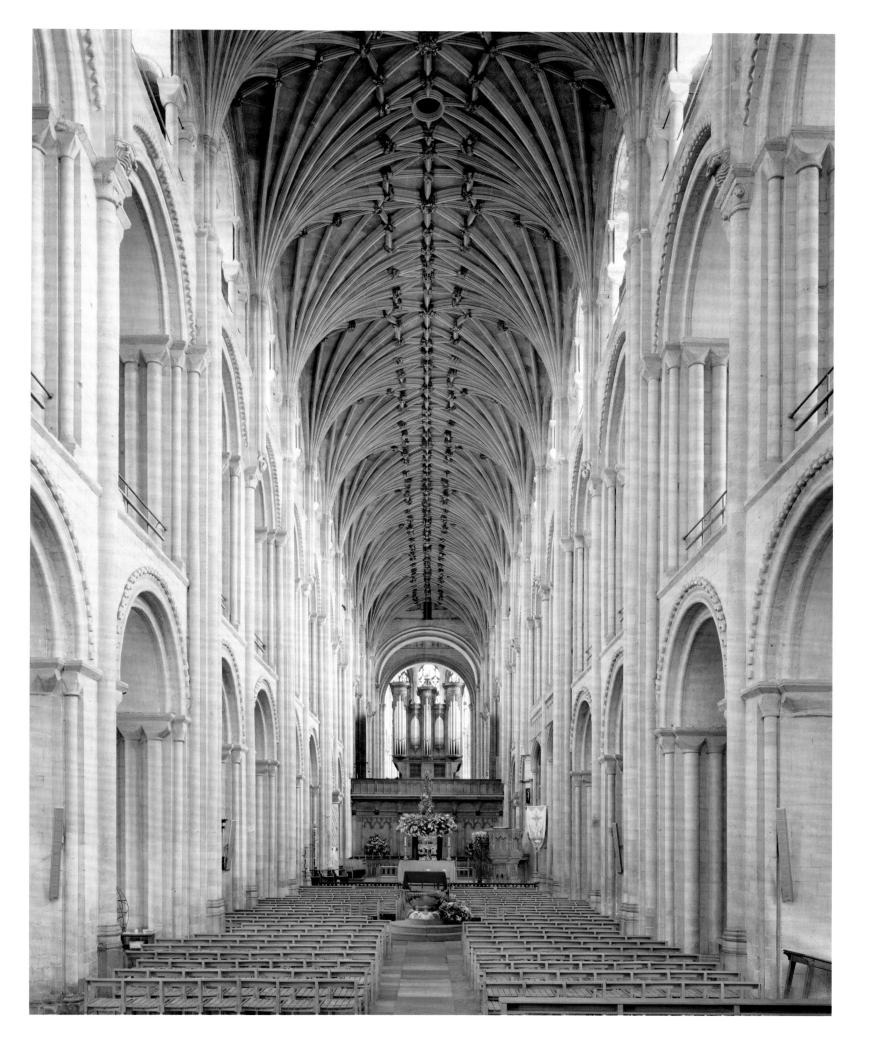

OXFORD

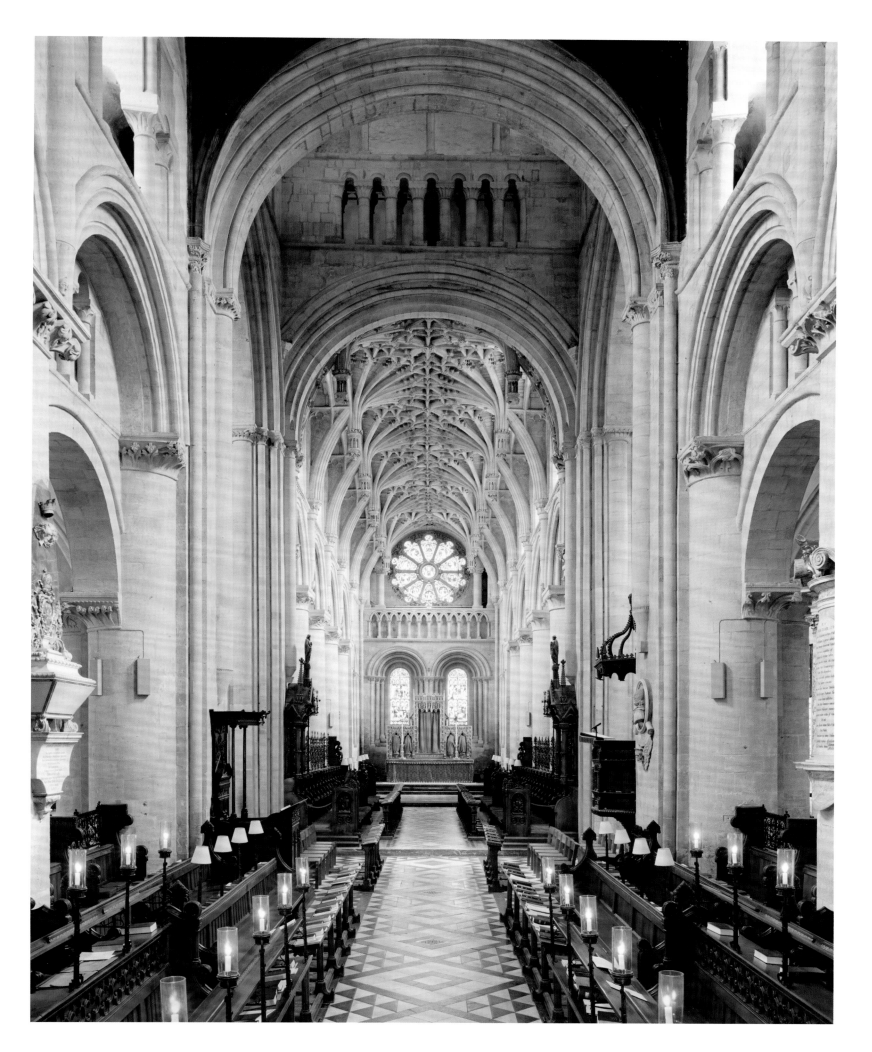

PETERBOROUGH

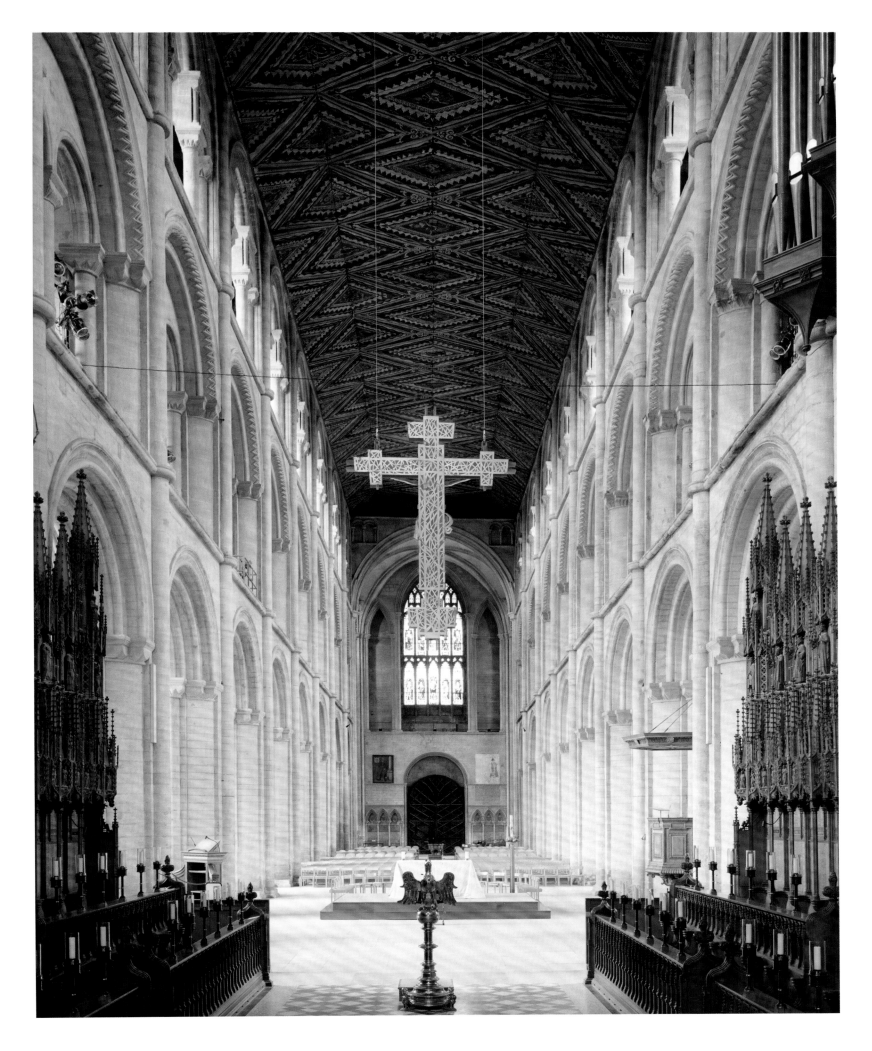

PORTSMOUTH

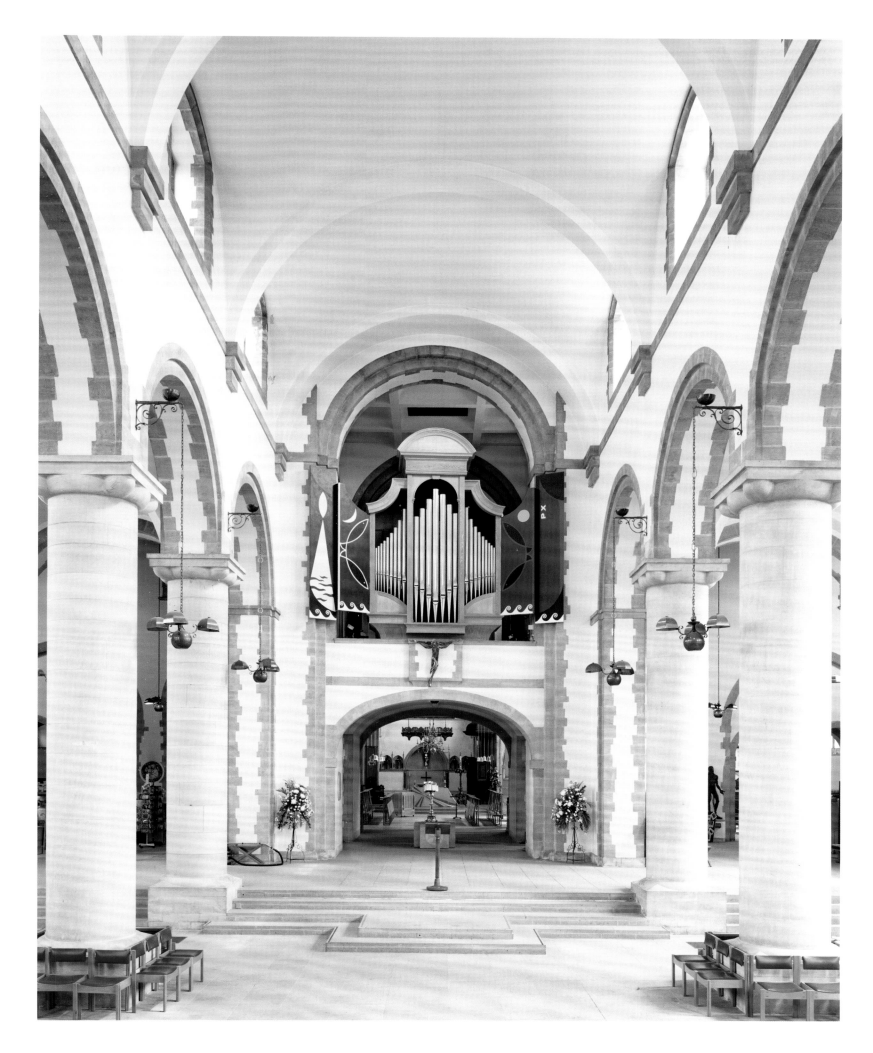

RIPON

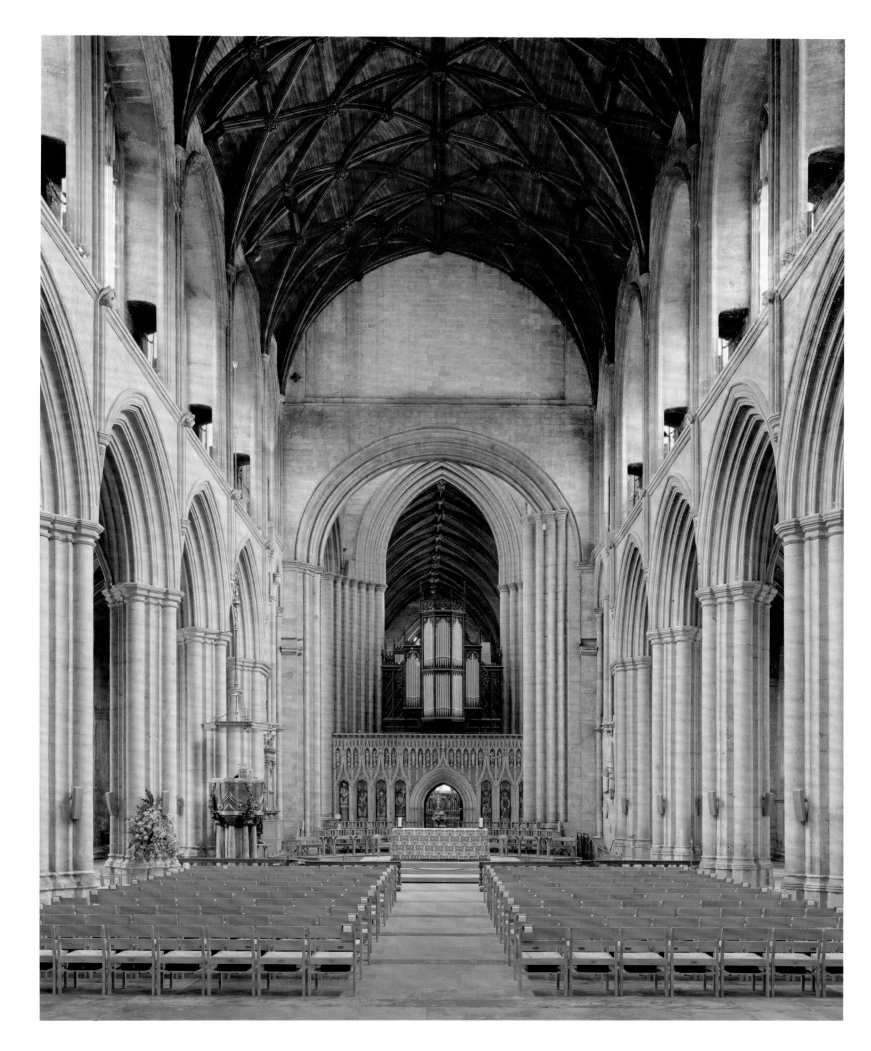

ROCHESTER

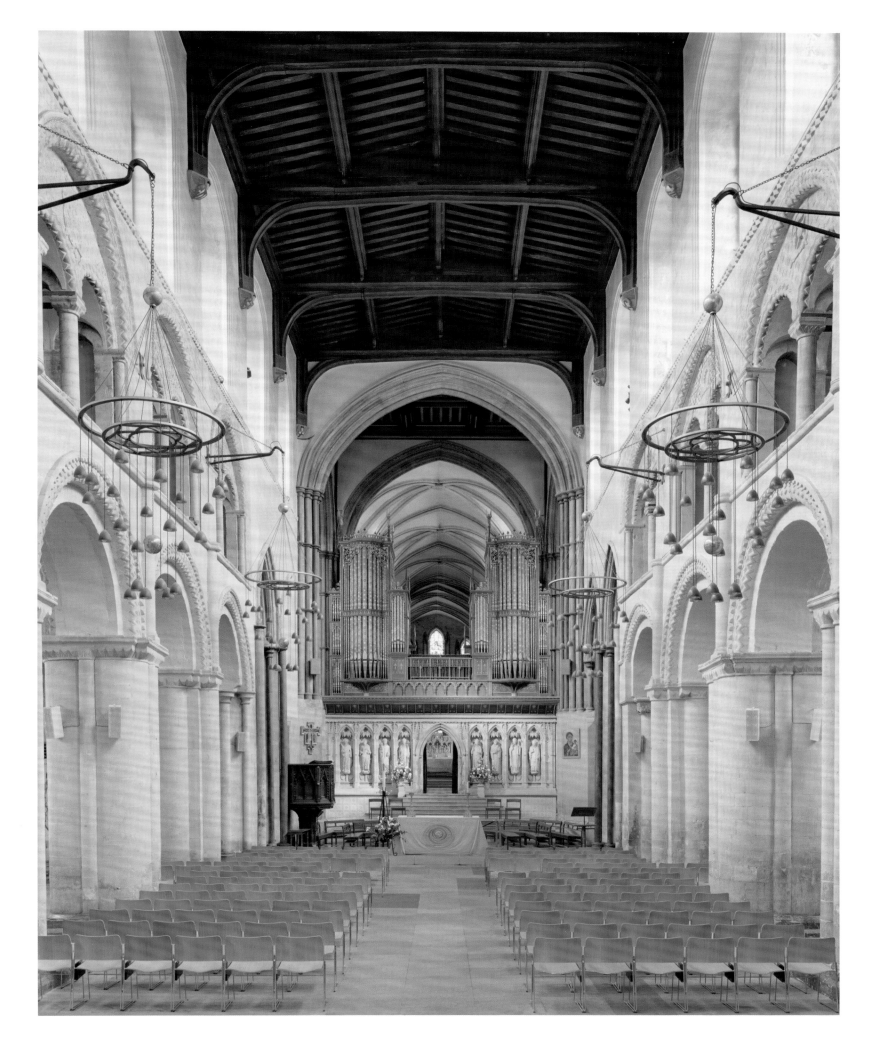

ST ALBANS

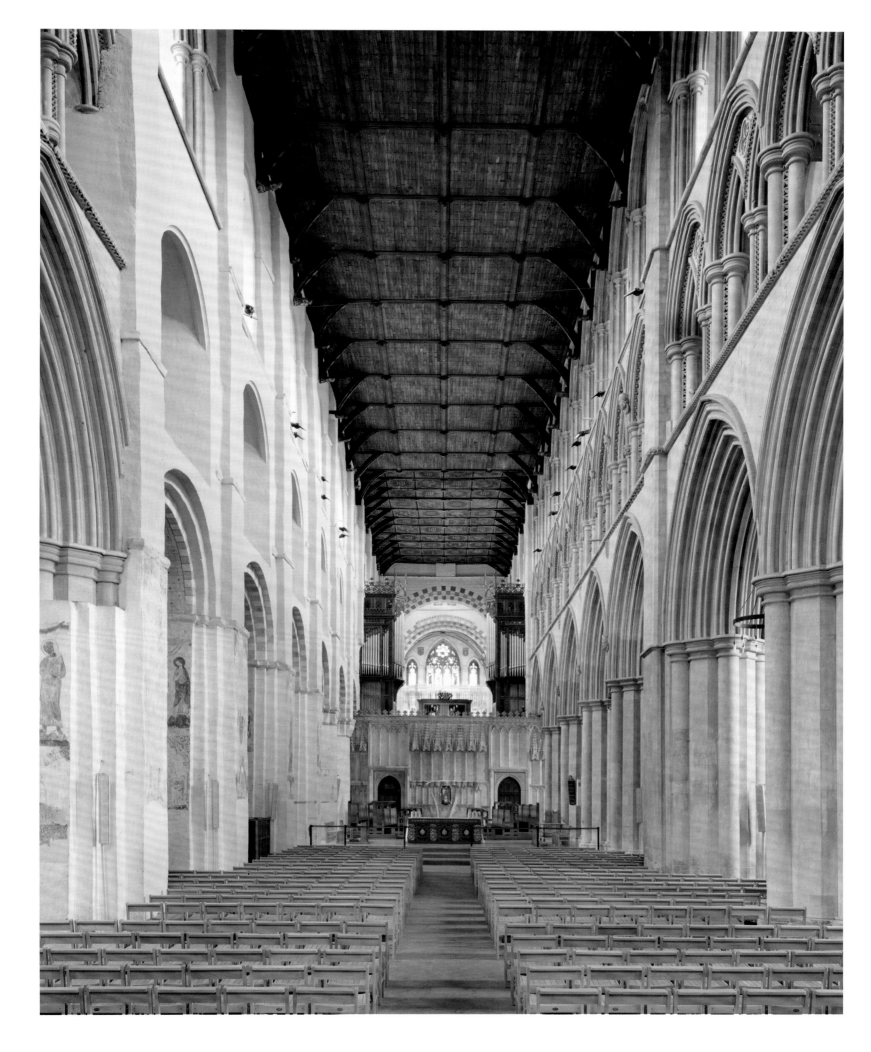

ST PAUL'S, LONDON

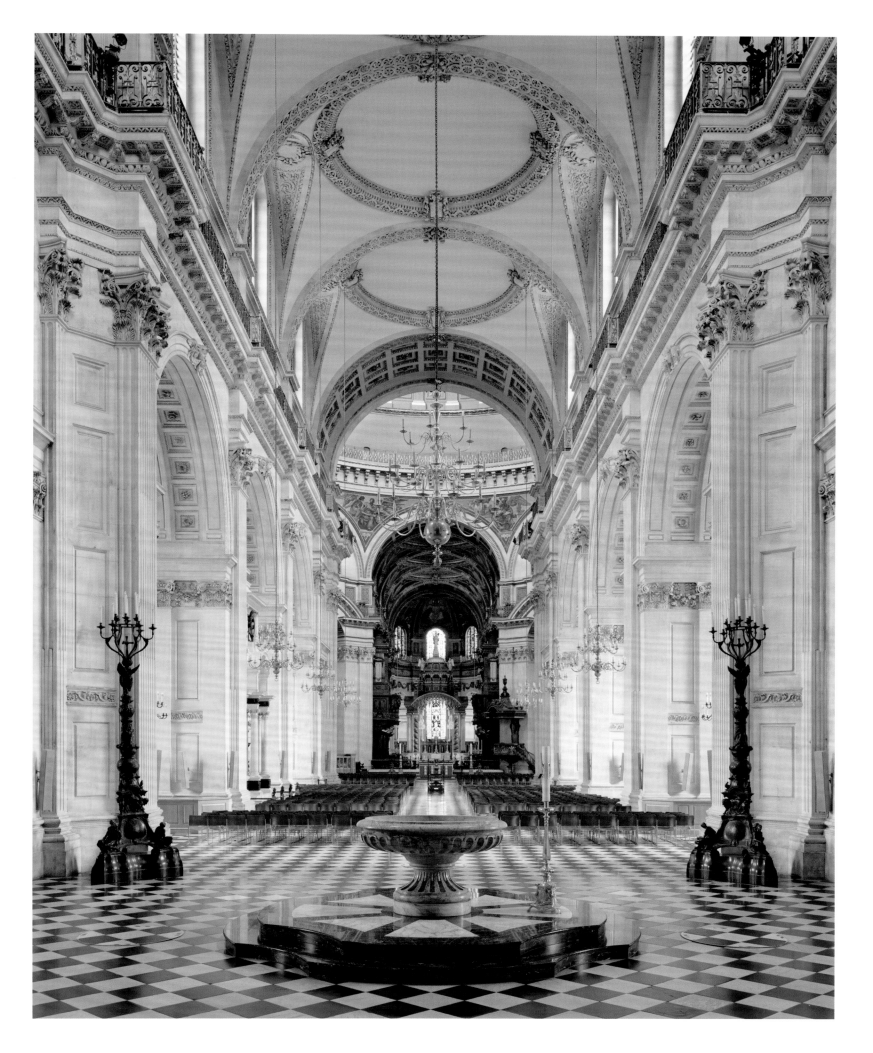

SALISBURY

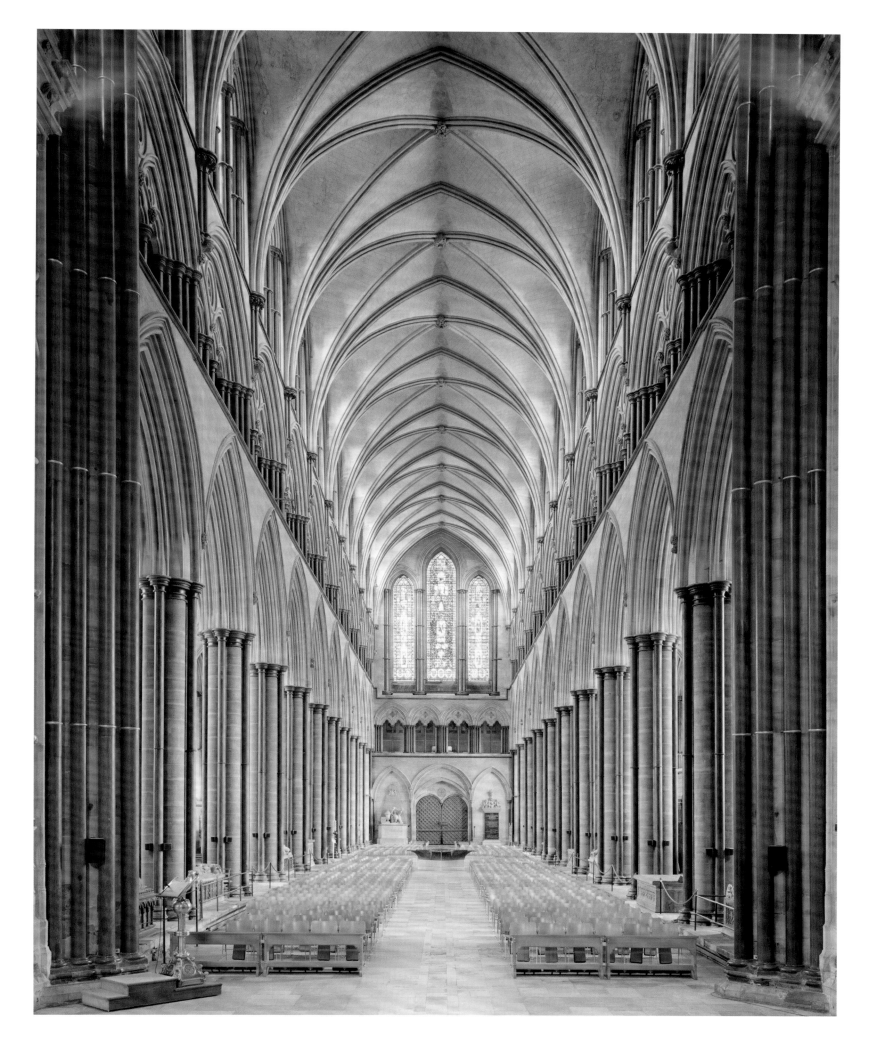

SHEFFIELD

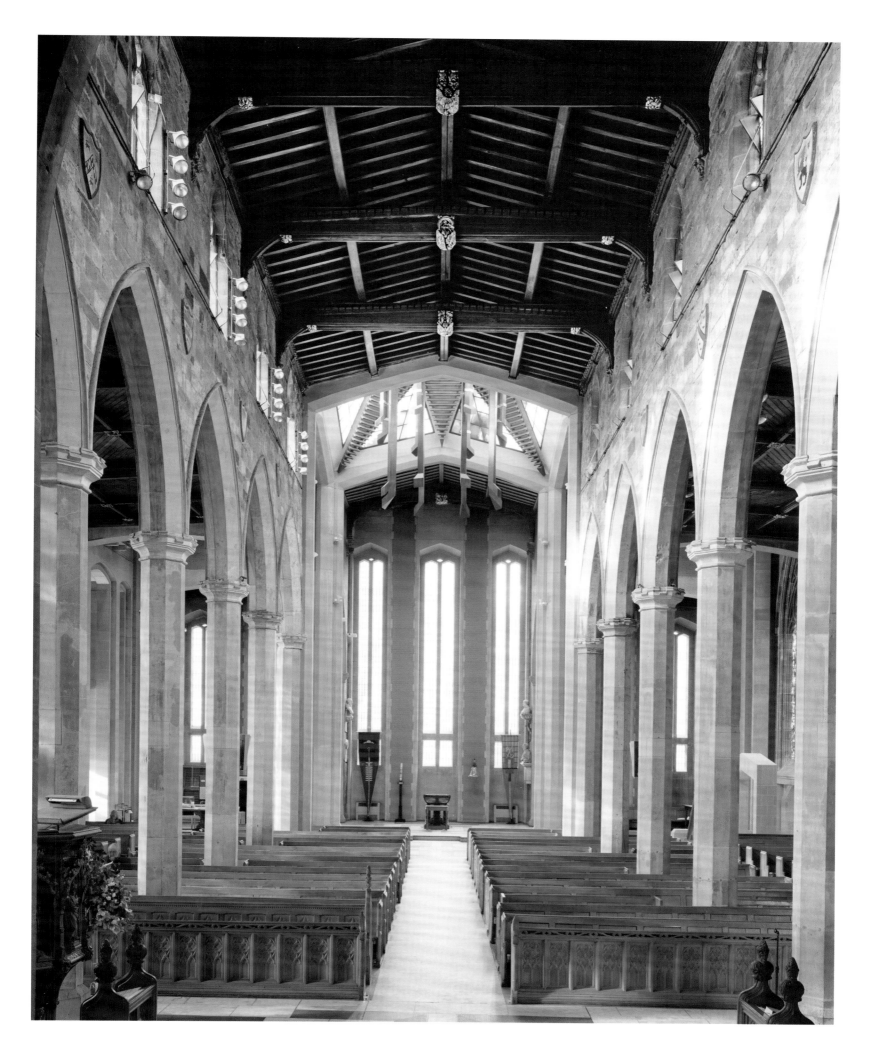

SOUTHWARK

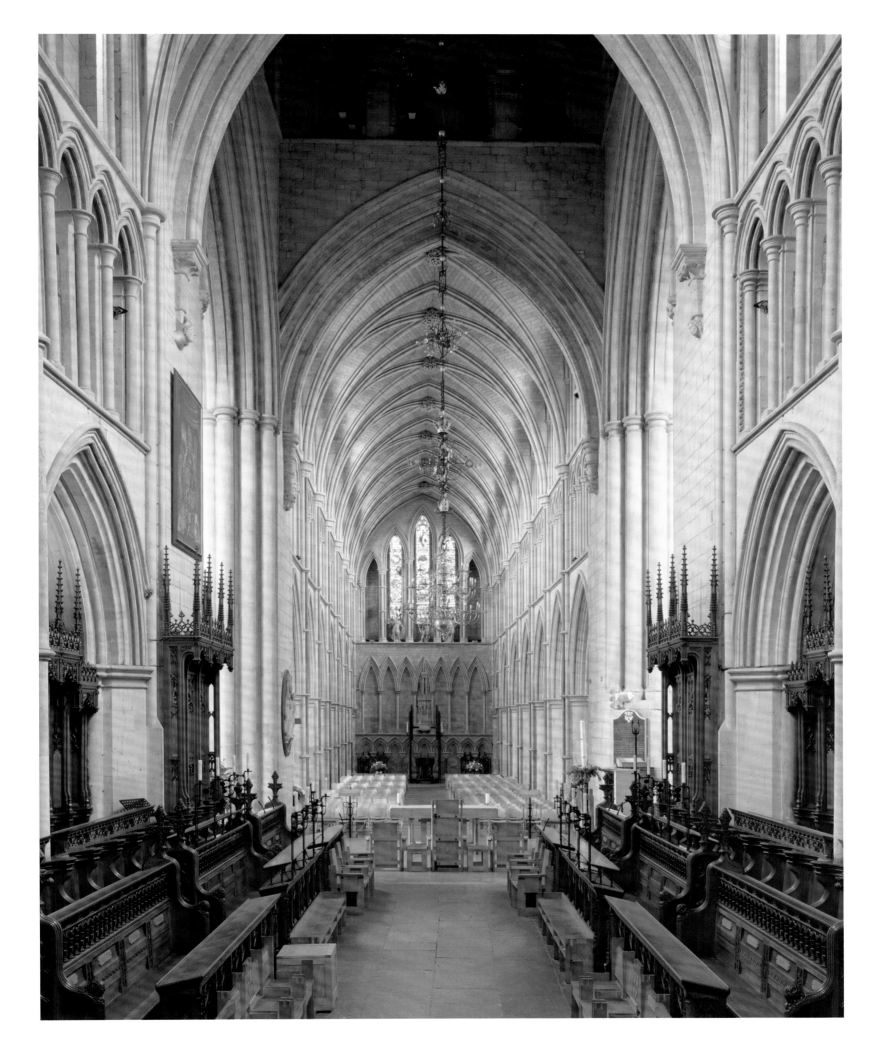

SOUTHWELL

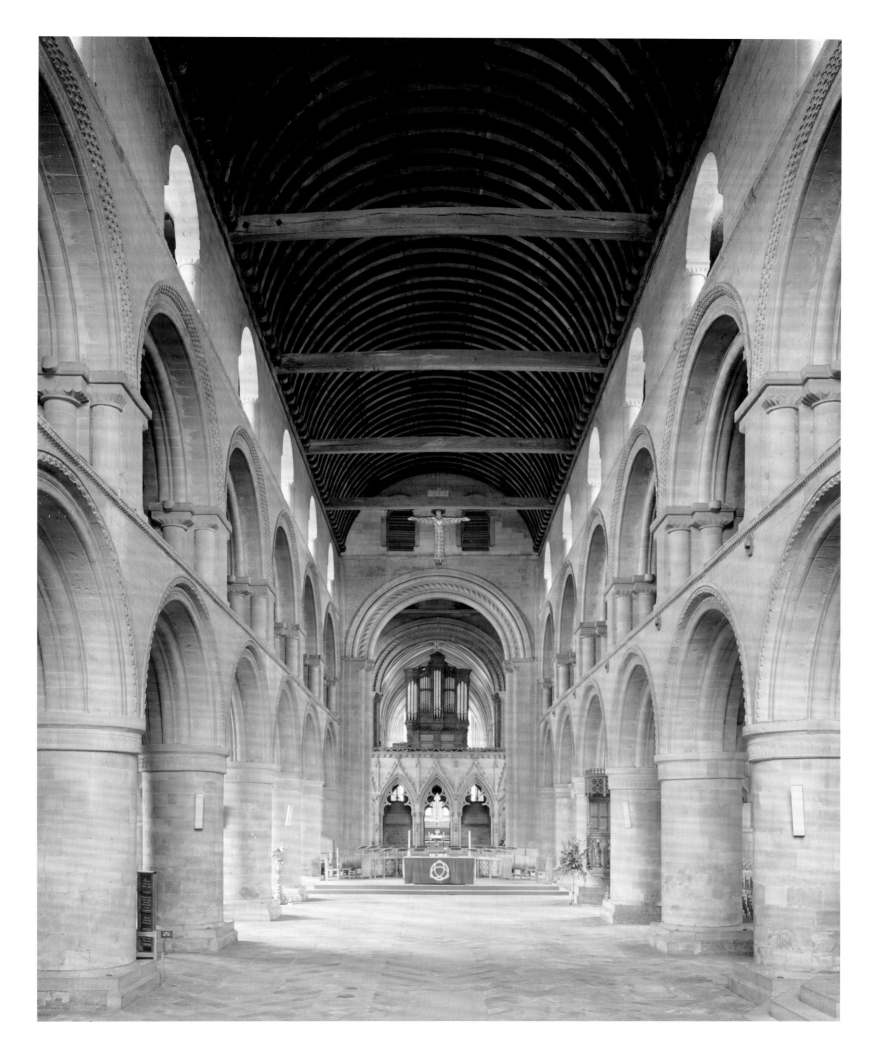

TRURO

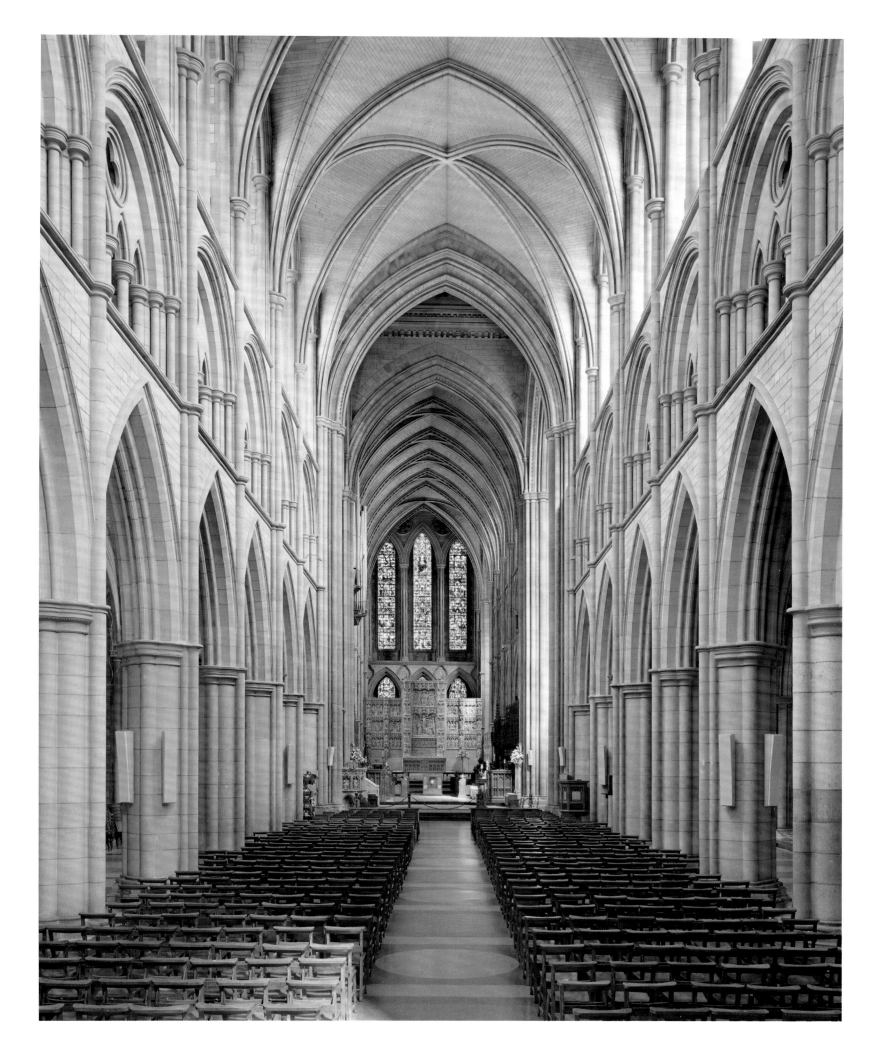

WAKEFIELD

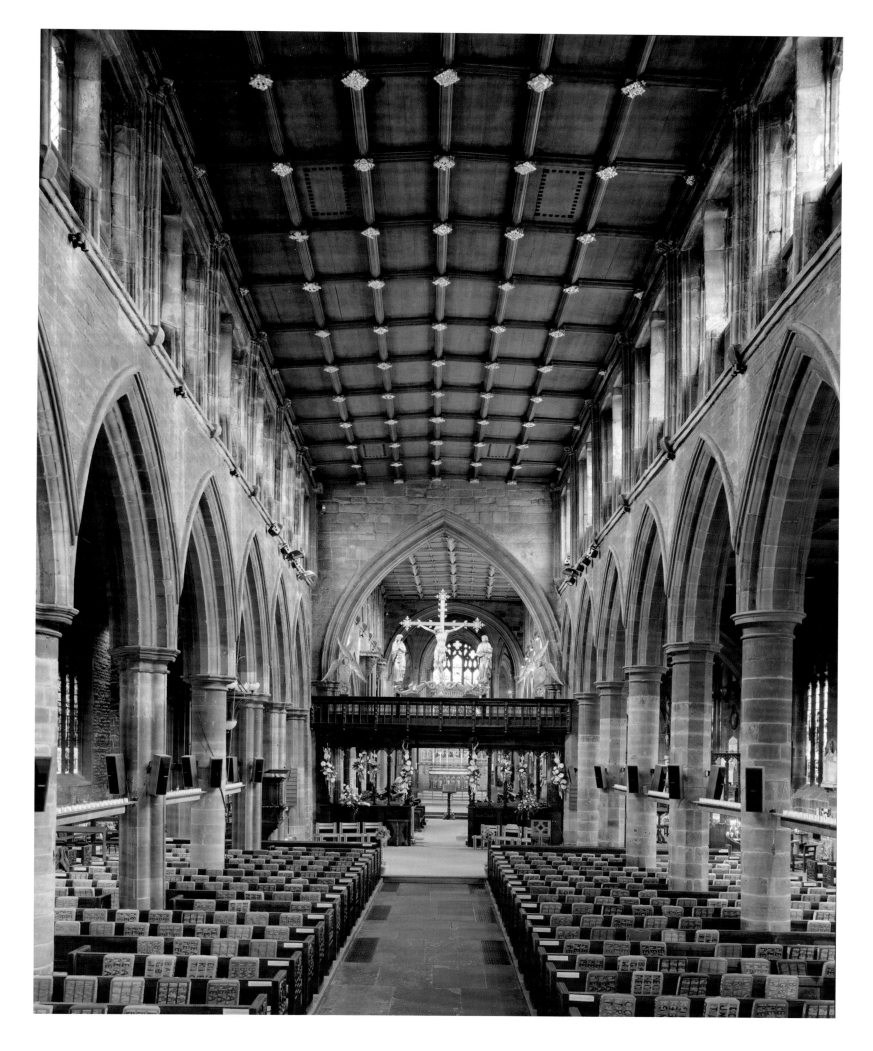

WELLS

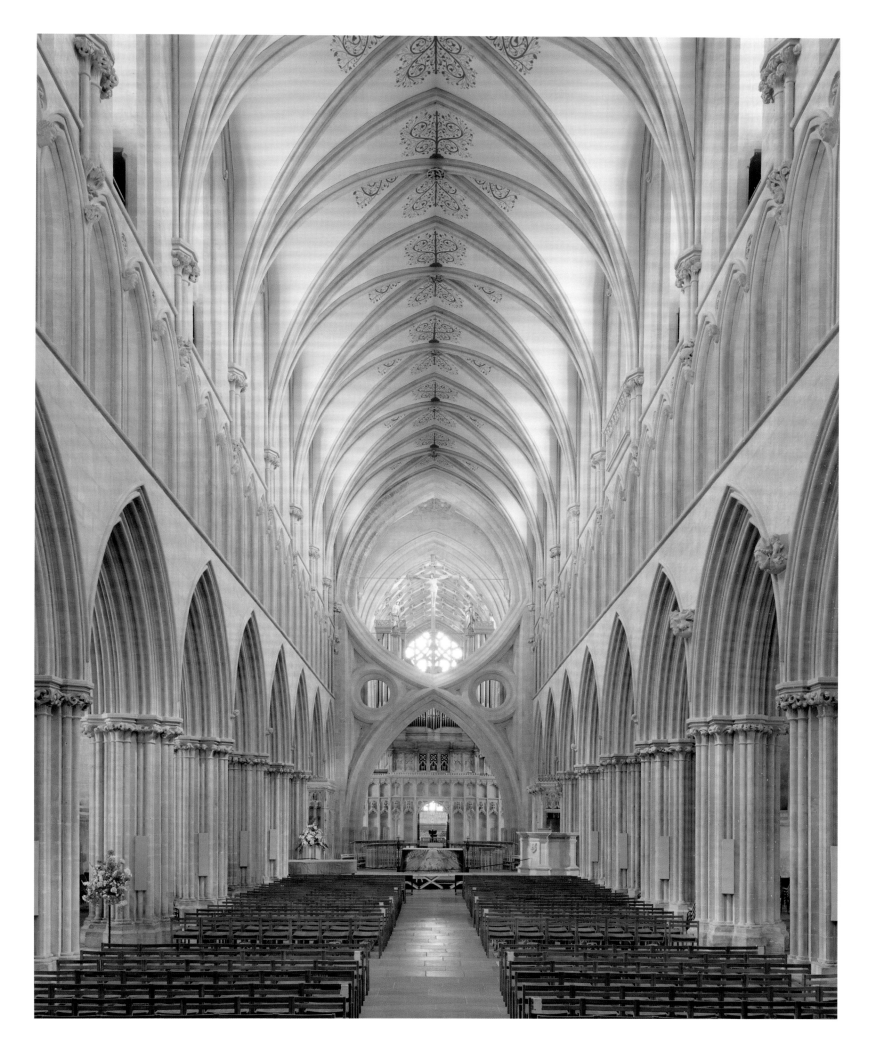

WINCHESTER

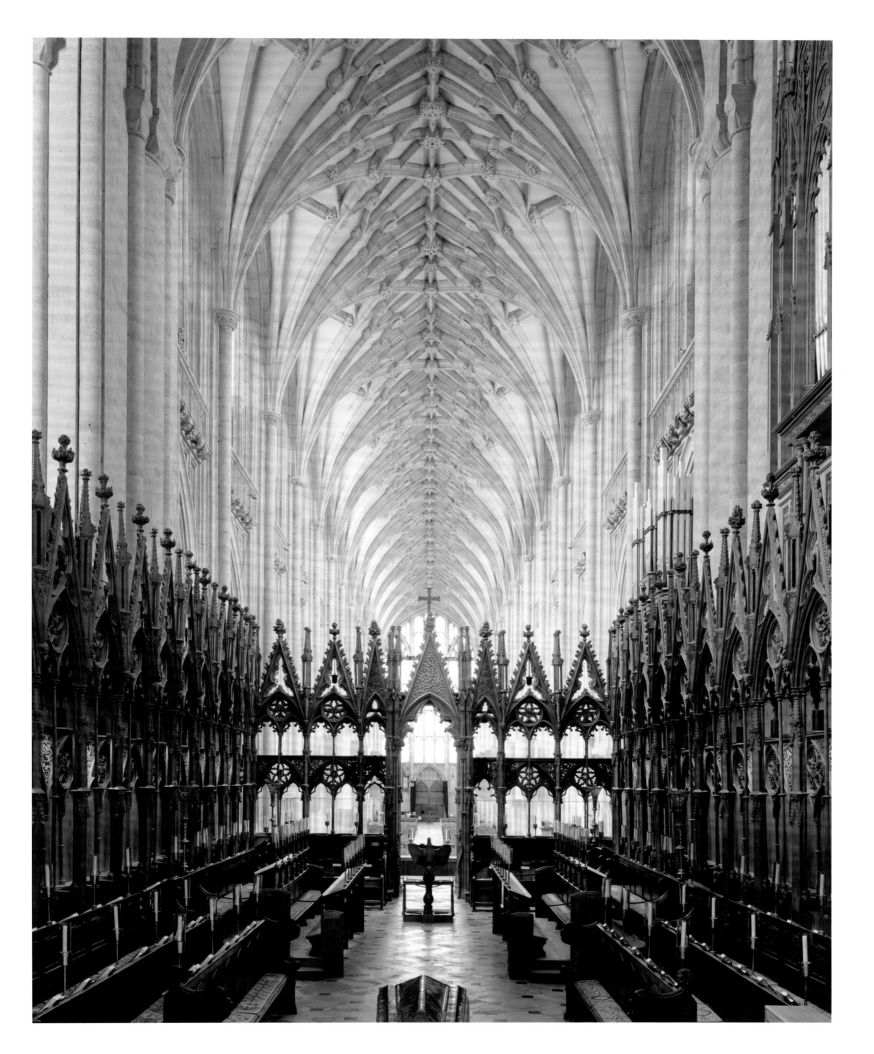

WORCESTER

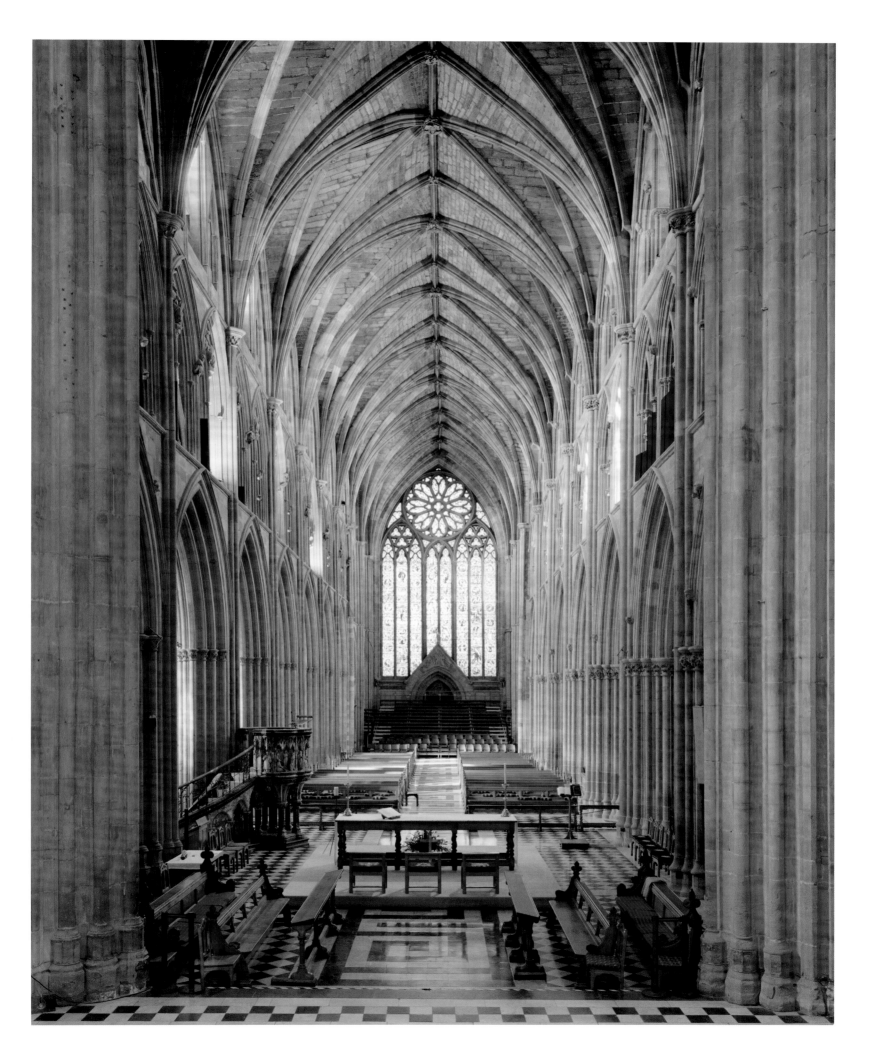

YORK

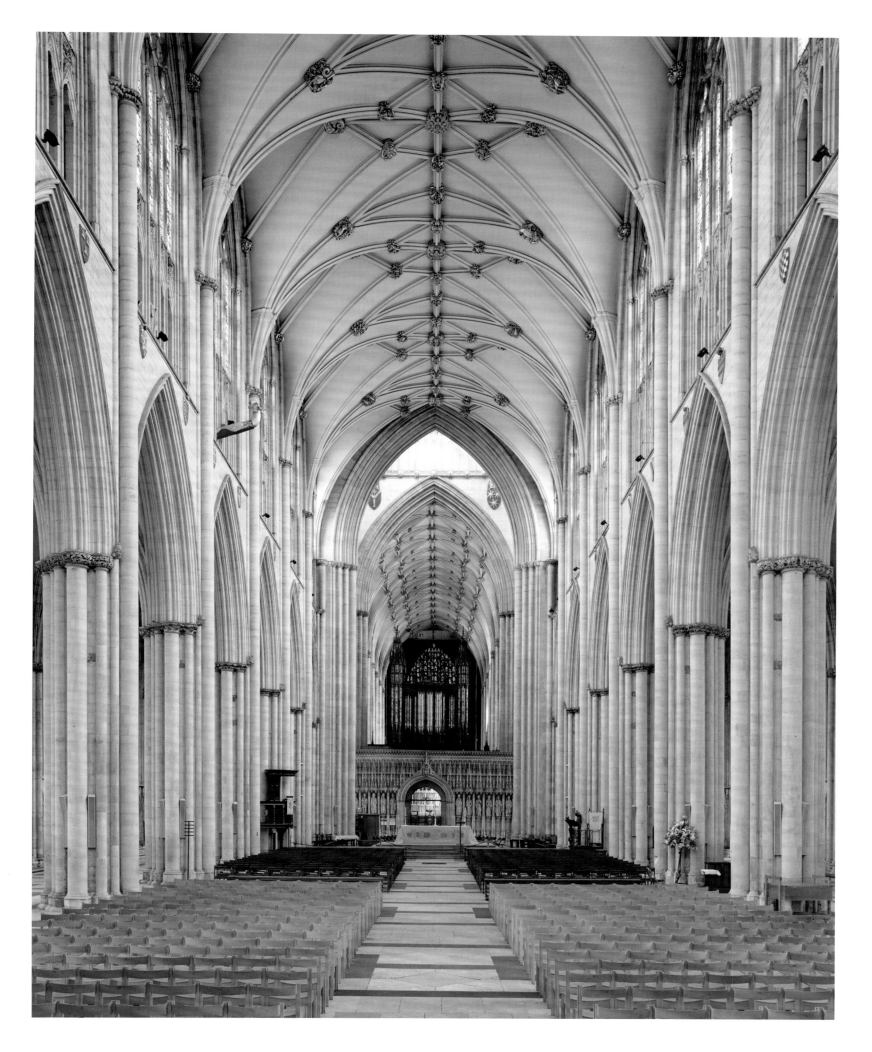

# COMMENTARIES

JOHN GOODALL

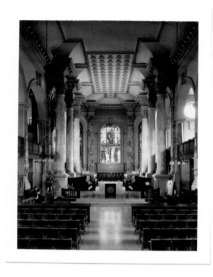

THE CATHEDRAL CHURCH OF ST PHILIP
BIRMINGHAM

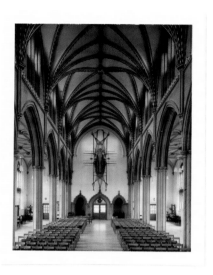

THE CATHEDRAL CHURCH OF ST MARY
THE VIRGIN WITH ST PAUL
BLACKBURN

In 1905 a cathedral was established in Birmingham, a wealthy city that had grown exponentially during the Industrial Revolution. The building appropriated for the purpose was a parish church built by the MP and gentleman architect Thomas Archer in 1710–15. This photograph looks along the length of the interior from the nave to the choir, which was greatly extended by the architect J.A. Chatwin in 1883–84 in a style appropriate to the original design.

Archer had travelled widely in Europe and acquired first-hand knowledge of architecture on the Continent. He was also one of the commissioners responsible for overseeing the construction of new churches in London following the Great Fire in 1666. Both experiences evidently influenced the design of this building. The nave is separated from the aisles by tall arcades with fluted columns. Surprisingly, no attempt was made visually to integrate the aisle galleries, with their plain oak panelling, into the architecture of the building; as a result, they slice awkwardly through the design. The interior is not vaulted but covered by a flat ceiling framed by deep coving. As befits its importance, the choir has a ceiling enriched by coffering. The eighteenth-century plasterwork is by Richard Hass.

The choir in its original form was smaller than at present, but likewise terminated in a semicircular apse. The stained glass in the central window of the choir depicts the Ascension. It was one of a pair of windows designed by Edward Burne-Jones and made by William Morris; the other, showing the Last Judgement, is at the opposite end of the building.

The parish church of St Mary in Blackburn became a cathedral in 1926. Plans were immediately put in hand to enlarge the east end of the building, preserving the existing nave. The rebuilding work was interrupted by the Second World War and completed only in 1977, although in 1998–99 structural failure demanded the reconstruction of the modern spire that forms the focus of the exterior.

This photograph shows the nave of the church looking west. Designed by the architect John Palmer and erected in 1820–26, it is detailed in the style of the early fourteenth century and has tall arcades to accommodate galleries within the aisles (now removed). Above the arcades is a high tier of windows termed a clerestory, the lower sections of which face into the aisle roof-space and are blank. All the stained glass in the nave has been removed, and consequently the interior is flooded with clear light. Following a fire in 1830 the architect Thomas Rickman rebuilt the vault of the nave in plaster, to modified designs. The vaults spring from triple shafts that rise up the walls above the arcades, and the roofs of the aisles are attractively finished with ribbed ceilings.

At the far end of the nave are three arches: a central door flanked by two vaulted niches. Above this composition is a large sculpture, *Christ the Worker* (1963–68) by John Hayward. A fibre-optic sculpture in the form of a large bronze disc, *The Healing of the Nations* by Mark Jalland, was erected in 2001 on the exterior of the east end.

The images on pp. 103–23 are the Polaroids used by Peter Marlow to test the exposure and composition of each photograph.

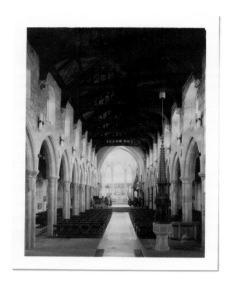

THE CATHEDRAL CHURCH OF ST PETER
BRADFORD

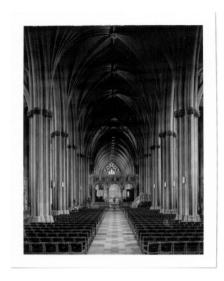

THE CATHEDRAL CHURCH OF THE HOLY
AND UNDIVIDED TRINITY
BRISTOL

The cathedral of Bradford was established in 1919 in what had been the parish church of the town. All that survives of the medieval building is the nave (shown here), which was erected following a fire in 1327; the transepts and east end were rebuilt in the nineteenth and twentieth centuries.

Visible in the distance is the eastern arm, built by Edward Maufe in the early 1960s. The three tall arches behind the high altar separate the choir from the Lady chapel beyond. The nave elevation comprises two storeys: an arcade at ground level and a clerestory above. Its architectural detailing is relatively rugged and characteristic of late medieval parish churches in this area. The principal timbers of the roof are supported on stone brackets carved in the form of angels, and are ornamented with screens of open tracery. Although heavily restored, the roof probably dates to the fifteenth century.

To the right of the view the tall timber pinnacle of a fifteenth-century font cover is visible. Each of its three main stages is richly ornamented with carving and tracery, and the cover can be raised and lowered on a counterweighted pulley. Such elaborate covers served to draw attention to fonts, but they could also be locked shut to secure the holy water. Since baptism marks the entry of Christians into the church community, medieval fonts are commonly located – as is the case here – close to the public entrance of the building, towards the west end of the nave.

In 1542 Henry VIII made the Augustinian Abbey of Bristol a cathedral with an attached see extending over the city and – bizarrely – the county of Dorset. At the time of this foundation, the abbey church was a building site, the nave having recently been demolished in preparation for its reconstruction. As a result, the splendid early fourteenth-century choir of the building along with the transepts and crossing constituted the original cathedral church. This medieval structure (visible in the background of this photograph, beyond the choir screen) was used as the inspiration for the present nave, which was begun only in 1868 by the architect G.E. Street.

The most distinctive feature of the choir – which is copied in the nave – is that the aisles are of equal height to the central vessel of the building. This means that no windows can be incorporated into the main elevations of the interior (except the large gable window above the high altar), and all the lighting must be borrowed from the aisle windows. The vaults within the aisles, meanwhile, are supported on arches that spring from the arcade capitals.

In this photograph it is possible to identify the different sections of the church from the treatment of the vault. The distant choir is covered in a complex vault that incorporates kite-shaped ornaments along its central section. This is a treatment not attempted by Street in the nave: his vault possesses a much simpler and more conventional pattern of ribs. Crossing arches set within the line of the vault clearly demarcate the position of the central tower. The choir furnishings – including a set of early sixteenth-century stalls with misericords – were reordered in the 1890s by the architect J.L. Pearson, who installed the high altar with its screen of saints.

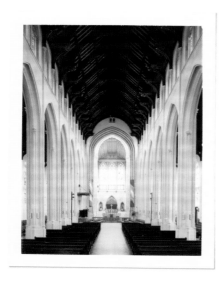

THE CATHEDRAL CHURCH OF ST JAMES
BURY ST EDMUNDS

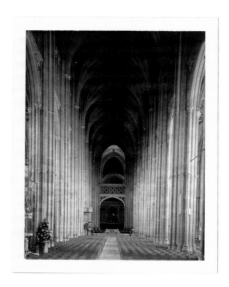

THE CATHEDRAL AND METROPOLITAN
CHURCH OF CHRIST
CANTERBURY

Bury St Edmunds takes its name from King Edmund of East Anglia, who was martyred by the Danes in 869 and became the patron saint of England (until he was displaced in the mid-fourteenth century by St George). Edmund's shrine stood in the great abbey church that dominated the town throughout the Middle Ages. Neither the shrine nor the monastery survived the Reformation, but when a new cathedral was founded in 1914 it was established in the former parish church of St James in the abbey precinct.

This photograph looks along the nave to the choir beyond. The nave was begun in 1503 and was probably designed by the mason John Wastell, a figure otherwise celebrated for his design of the fan vaults at King's College Chapel, Cambridge, and of Bell Harry, the central tower of Canterbury Cathedral. Bury's two-storey elevation composed of elegant, economical and abstract forms is typical of Wastell's work. Over the nave is a much later hammer-beam roof, erected in 1862–64 by the architect George Gilbert Scott, who restored the church. It springs from delicate shafts that rise the full height of the interior. The roof imitates the forms and colours of local late medieval church roofs, and is decorated with the figures of angels.

Beyond the crossing arches can be seen the choir, which was begun in its present form to the design of the architect Stephen Dykes Bower in the 1960s. Dykes Bower, who died in 1994, left £2 million in his will towards work to the cathedral, and in 2005 a new crossing tower in a late Gothic idiom was completed by his designated successor, Warwick Pethers.

Canterbury is the mother church of Christianity in England. The first cathedral here was started soon after the arrival in 597 of St Augustine's mission from Rome to convert the English. Its immense nave, built in the late fourteenth century and shown in this photograph, is the product of a very unusual brief. The designer – almost certainly the prolific king's master mason Henry Yevele – was instructed to preserve in his new work the principal levels of the late twelfth-century choir. Because the choir is raised above a crypt, the columns of the nave had to be elongated to effect this visual continuity. The result is a majestic elevation supported on vastly tall arches and flooded with light from commensurately scaled aisle windows.

In the late Middle Ages a tall iron grille crossed the nave to secure its farther end from public access without interrupting the spatial effect of the architecture. The interweaving vaulting pattern draws the eye through the length of the nave, while the collars of stone that punctuate the gigantic shafts of the arcade permit the eye to read the regularity and scale of the space. At the far end of the nave, a broad flight of steps leads up to the stone screen that closes off the monastic choir. One of the arches bracing the crossing piers is also visible.

The inherited levels of the nave paid architectural tribute to the choir and its precious contents: the shrine of St Thomas Becket, the archbishop of Canterbury famously murdered for his opposition to Henry II in 1170. On the eve of the Reformation, the shrine had attracted probably the single most valuable assemblage of art that has ever existed in England. It was carted away at the Reformation as twenty-six cartloads of bullion in 1538.

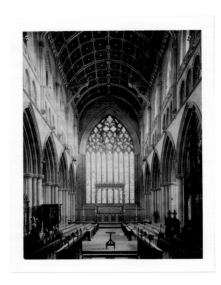

THE CATHEDRAL CHURCH OF THE HOLY
AND UNDIVIDED TRINITY
CARLISLE

In 1133 Henry I made the recently founded Augustinian monastery in the former Roman city of Carlisle the seat of a new cathedral. Little survives of the original monastic church. Much of its nave was demolished in about 1649, and the choir was entirely rebuilt in the thirteenth century. The replacement choir, shown here, is the product of two phases of rebuilding: the first begun in 1218 and the second following a destructive fire in 1292.

As completed, the interior comprises three storeys: a tall and richly decorated arcade supporting a triforium and clerestory. A spectacular barrel vault of timber covers the interior. The structure of the roof is medieval and its timbers have been dated by their tree rings to the 1350s; unfortunately, however, the original covering boards on the interior were replaced during the nineteenth century. Their present decoration was devised in 1856 by the celebrated designer Owen Jones, and the colouring was renewed in 1970.

The interior of the choir is dominated by the huge nine-light east window, which was probably completed in the first half of the fourteenth century. Panels of medieval glass depicting the Last Judgement survive in the upper parts of the window. These were restored and the remainder of the window filled with new glass in an appropriate style by the Newcastle glazier William Wailes between 1856 and 1861. At the far end of the choir is the high altar and baldachin designed by the architect Charles Nicholson in 1936. On the left of the photograph is a sixteenth-century pulpit from Antwerp, one of several furnishings imported to the cathedral from the Continent during the nineteenth century. On the right is visible the pinnacle of the bishop's throne, an addition of the 1880s to the fine series of early fifteenth-century choir stalls that survives at Carlisle.

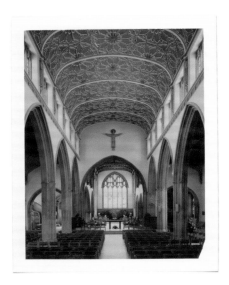

THE CATHEDRAL CHURCH OF ST MARY THE VIRGIN,
ST PETER AND ST CEDD
CHELMSFORD

The parish church of St Mary at Chelmsford was transformed into the cathedral of Essex in 1913. This view of the interior looks through the length of the nave towards the choir. While this building is in origin a medieval structure, the present form of the interior is substantially the product of restoration and extension over the last 200 years.

The excavation of a burial vault in 1800 caused much of the medieval nave to collapse. It was rebuilt by John Johnson, who reproduced the original medieval detailing of the south arcade (to the right) using a patented artificial material called Coade stone. Johnson also erected the clerestory and created the curious vault, ornamented with rosettes of Gothic tracery. Between the clerestory windows are draped female figures standing on the heads of cherubs. In 1899 Johnson's aisle ceilings were replaced with wooden roofs in a design based on surviving fifteenth-century roof timbers.

The choir was extended by two bays in 1923–26 by Charles Nicholson. Further alterations were made throughout the church in 1983–84, when the interior was reordered by Robert Potter. He relaid the floor and installed a new high altar at the end of the nave. The stone bishop's throne carved from Westmoreland slate by John Skelton and installed in 1983 is just visible in the centre of the choir beyond. Stephen Dykes Bower designed the rich colouring of the roof above the choir in 1957 (shortly before the nave vault was painted, in 1961). To either side of the chancel arch are pulpits or ambos of steel and bronze by Giuseppe Lund (1983).

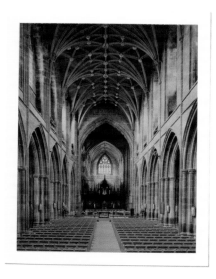

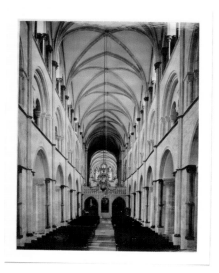

THE CATHEDRAL CHURCH OF CHRIST
AND THE BLESSED VIRGIN MARY
CHESTER

THE CATHEDRAL CHURCH OF THE HOLY TRINITY
CHICHESTER

Henry VIII elevated the monastic church of St Werburgh at Chester to the status of a cathedral in 1541. The body of St Werburgh, a seventh-century princess who became an abbess, had been brought to the town in 875 from Hanbury, near Utoxeter. Chester briefly served as a cathedral city in the tenth century, and in 1092 the future cathedral became a Benedictine monastery. This photograph shows the view from the fourteenth-century nave into the choir. The interior bears the stamp of a heavy restoration by George Gilbert Scott, who was active at Chester from 1859 to 1876.

As is typical of England's great church interiors from the fourteenth century onwards, the nave elevations are two-storeyed, with an arcade at ground level (supported on piers carved to suggest clusters of shafts) and a clerestory above. There must always have been the intention to vault the nave, but the present structure is in fact a creation of Scott's restoration. It is built of timber and covered by a complex lattice of ribs studded with bosses. The vault springs from a series of insubstantial shafts that rise the full height of the elevation from the ground.

Separating the nave from the choir is an elaborate timber screen by Scott, and to the left is an organ case, partly by him, which stretches up impressively to the vault. The choir was rebuilt in the thirteenth century and preserves an important collection of stalls dating to about 1380. At the end of the choir is a large elevated window and beneath it an arch to the Lady chapel beyond. The reconstructed remains of St Werburgh's shrine, created in the 1340s, stand in their medieval position on the far side of the arch.

In 1075 the bishopric at Selsey, founded in the seventh century by St Wilfrid, was moved to a new site in the former Roman city of Chichester. Work began soon afterwards to a new church, the remains of which are encased in the present building. This photograph shows the nave with the choir beyond. Dividing the two is the late fifteenth-century Arundel screen, which was dismantled from this position in 1859 and restored here in 1960.

The eleventh-century cathedral was laid out on a cross-shaped plan with an internal elevation of three storeys and a timber ceiling. No sooner had the building been substantially completed than a serious fire gutted the interior, on 20 October 1187. During the course of rebuilding, the existing fabric was reworked. New shafts and capitals in a dark, polished limestone called Purbeck Marble were installed in the nave to create a contrast of colour. At the same time, the upper storey of the building – the clerestory – was rebuilt to accommodate high vaults, which were supported in the nave on delicate triple shafts that extend from the ground to the spring of the vault. Some small changes were made to the design in the course of work, such as the insertion of collars round the arcade shafts in the three bays closest to the viewer in this image. Meanwhile the apsidal choir was extended and rebuilt with a flat east end.

In 1276 the remains of St Richard, a former bishop canonized in 1262, were translated into a shrine beyond the high altar in the new eastern arm. On 21 February 1861 the spire of the cathedral collapsed and demolished the crossing of the church; it was rebuilt in its present form by George Gilbert Scott.

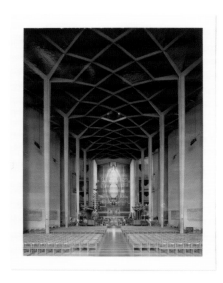

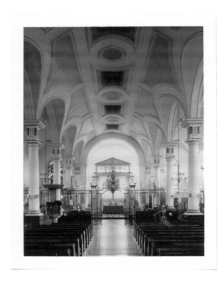

THE CATHEDRAL CHURCH OF ST MICHAEL
COVENTRY

THE CATHEDRAL CHURCH OF ALL SAINTS
DERBY

The only medieval cathedral in England to be demolished at the Reformation was at Coventry. The site of that important monastic church – which was linked to Lichfield – was excavated in the 1990s. It was not until 1918 that a cathedral was again established in the city, in the great medieval parish church of St Michael. The huge spire of St Michael's still dominates Coventry, but the church itself was reduced to a shell by incendiary bombs on 14 November 1940. The present cathedral, designed as a replacement by the architect Basil Spence, was erected between 1956 and 1962. Spence's cathedral, shown here in a view from the nave with the high altar in the distance, is laid out at right angles to its predecessor and connected to it by a porch.

Spence's design, with its aisles and high vault, is inspired by medieval precedent. Built in concrete, however, and exploring the structural possibilities of modern materials, it is also a self-consciously twentieth-century creation. The net vault, supported on the slenderest of columns, visually integrates the whole space. All the windows along the side of the building are raked forward, an arrangement that renders them invisible from this viewpoint and throws light on to the high altar.

The church has a celebrated collection of furnishings by many outstanding artists of the period. Most striking is Graham Sutherland's 74-foot-high (22.5 m) tapestry of *Christ in Glory in the Tetramorph* that dominates the interior. Made in France using wool from Australia, it is the largest tapestry in the world. To underline the open character of the interior, the canopies of the stalls and bishop's throne are skeletal and abstracted. The chairs in the nave were specially designed by Gordon Russell and made at his factory in the Cotswolds.

In 1927 Derby's principal parish church, which had been served by a college or community of priests before the Reformation, was made into the cathedral of a new Derbyshire diocese. All that survives of the medieval building is a splendid west tower with the oldest peal of ten bells to survive in the country; this view from the nave into the chancel shows the building that replaced it.

In February 1723 the vicar of Derby, Dr Michael Hutchinson, began demolishing the medieval church in protest at the failure of the town council to repair the fabric. He subsequently raised enough money to rebuild it. The architect employed was James Gibbs, a figure perhaps most celebrated for his design of St Martin-in-the-Fields in Trafalgar Square, London. Gibbs's new church at Derby was divided into three aisles of equal height by columns standing on tall bases to accommodate box pews (now replaced by standard pews). A magnificent iron screen of 1730 by a brilliant local smith, Robert Bakewell, divides the nave and chancel.

In 1965 the choir was extended by Sebastian Comper (the son of the celebrated church architect Ninian Comper), who created the high altar and its surrounds. The pulpit to the left and the choir stalls were designed in the late nineteenth century by Temple Moore. To accommodate the natural fall of the ground, the choir extension was raised above a crypt. The church contains an important collection of funerary monuments, many of them preserved from the old church. That of the Countess of Shrewsbury, familiar today as Bess of Hardwick, is partially visible on the right of the photograph.

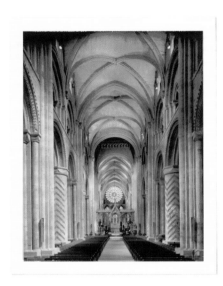

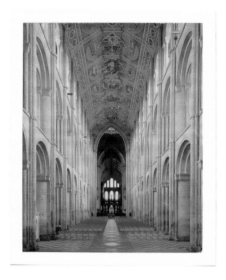

THE CATHEDRAL CHURCH OF CHRIST, BLESSED MARY
THE VIRGIN AND ST CUTHBERT
DURHAM

The body of St Cuthbert, Bishop of Lindisfarne in the seventh century, was brought to Durham in 995 by a party of monks. Their monastic church, completed by 998, became a cathedral, and through the influence of St Cuthbert its bishops came to enjoy 'palatine' or regal powers over the see of Durham in the late Middle Ages.

In 1093 work began to replace the first church with a vast new structure. This building, which is still substantially preserved, is one of the acknowledged masterpieces of European Romanesque architecture. The nave elevations are three storeys high and massively built to support a stone vault ornamented with ribs of stone. An architectural commonplace in the later Middle Ages, the idea of vault ribs may have been invented at Durham. Dividing the nave bays into pairs are clusters of shafts, which rise the full height of the interior and support arches that span the vault. The interior effect is of solemn grandeur, but the decoration of the intermediary columns of the arcade with abstract patterns and the ornamental use of shafts give relief and interest to the design.

The choir is today separated from the nave by a rich marble screen designed by George Gilbert Scott and installed in 1876. Scott also erected the pulpit to the right of the screen. The eagle lectern on the left was designed by D. McIntyre in 1934. At the far end of the building is visible the celebrated fourteenth-century reredos or backdrop to the high altar, known as the Neville screen. Above it can be seen the rose window that lights the chapel of Nine Altars, a thirteenth-century extension of the church beyond the shrine of St Cuthbert.

THE CATHEDRAL CHURCH OF THE HOLY
AND UNDIVIDED TRINITY
ELY

In 1083 Abbot Simeon of Ely began the complete reconstruction of his church in the town. The monastery, founded by St Etheldreda (or Audrey) in 673, was one of the richest, oldest and most powerful Benedictine houses in England. In 1106 the choir of the new building was largely complete, and three years later the church became the seat of a new bishopric carved out from the vast diocese of Lincoln.

This photograph shows the view down the full length of the church. In the foreground is the Romanesque nave, which was probably completed by about 1150. It is a massive structure three storeys high with absolutely consistent detailing. The arcade at ground level alternates drum and shafted supports, and each bay is demarcated by a single shaft that rises from floor to ceiling. Covering the whole structure is a nineteenth-century timber ceiling painted by H.S. Le Strange and completed by Thomas Gambier Parry.

Just visible beyond the nave is the octagon, which was created following the collapse of the central tower on 22 February 1322. This huge volume, which was vaulted in timber, had no parallel in scale or character in Britain until the dome of St Paul's, London, was completed in 1708. In the distance is the choir with its cliff-like east end lit by tiers of windows. The far end of the choir was built between 1234 and 1252, but the nearer section was erected as part of the reconstruction of the church following the tower collapse. Just legible in the contrasting detailing of the choir vault is the break between the two sections of the building.

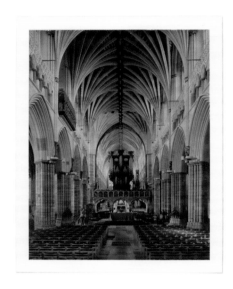

THE CATHEDRAL CHURCH OF ST PETER
EXETER

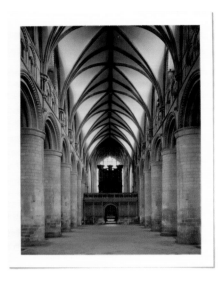

THE CATHEDRAL CHURCH OF ST PETER
AND THE HOLY AND INDIVISIBLE TRINITY
GLOUCESTER

In 1050 Edward the Confessor moved the cathedral of Devon from Crediton to Exeter. It was not until the early twelfth century, however, that work began to a cathedral on the site of the present building. Little of that structure now survives because, in the 1270s, Bishop Walter Branscombe initiated the complete reconstruction of the church. Work began in the Lady chapel beyond the high altar and culminated with the western entrance front a century later, in the 1370s. As this view from the nave towards the choir shows, the interior is unusually coherent. The church is covered in stone vaulting that runs unbroken the full length of the building and serves to draw the eye along the interior; it is one of several details that lend the space a horizontal rather than a vertical accent.

The interior reflects a fascination in English art from the late thirteenth century with rich surface ornament. Every element of the design is broken down into multiples to create an impression of exquisite detail and architectural movement. The surface of the vault, for example, is covered in ribs, and each pier of the arcade is notionally supported on clusters of sixteen shafts. From these spring arches laden with richly moulded detail. High in the nave wall to the left is a musicians' gallery carved with the images of angels playing instruments. This survival hints at the importance of music in the cathedral's medieval liturgy.

Dividing the nave from the choir is a pulpitum screen, erected between 1318 and 1325. Clearly visible to the right of the organ is the tall timber spire of the bishop's throne, which was completed in 1312 by the master carpenter Robert Gampton, probably to the design of the master mason William of Witney.

Henry VIII made the great Benedictine monastery at Gloucester into a cathedral in 1541. The abbey traced its history back to the late seventh century, but the present church was begun by Abbot Serlo in 1089. This photograph shows the view down the nave towards the choir. Separating the two liturgical spaces is a stone screen installed in 1823 by the architect Robert Smirke; the organ case above it is by Thomas Harris and dates to 1665.

The nave elevations resolve themselves visually into two sections, the lower of which is formed by the tall, plain drum columns that support the building. Elongated columns of this kind are found in other nearby Romanesque churches, such as Tewkesbury Abbey. Rising above the columns is the second section of the elevation: three tiers of arches dense with carved ornament. The vault, supported on clusters of shafts set high in the walls, is an insertion of the thirteenth century. A line of bosses ornaments the continuous rib that runs the length of the building along the apex of the vault. The idea of enriching vaults and visually integrating their surface decoration fascinated English masons, and was startlingly developed in the fourteenth-century changes to this building.

In the distance is the soaring interior of the choir, completed in about 1368. Amazingly, this interior cannibalizes the Romanesque fabric of its predecessor, which is concealed behind a skin of delicately moulded masonry. The choir terminates in a huge three-part window, which appears here as a wall of glass, an effect contrived by splaying the last bay of the building outwards. The vault seems to spring seamlessly from the shafts that rise up the walls. It is ornamented with a web of ribs and bosses, a net-like pattern of decoration that ignores the bay divisions of the building.

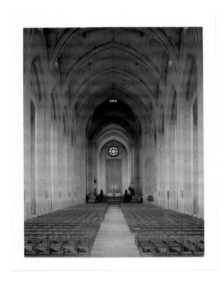

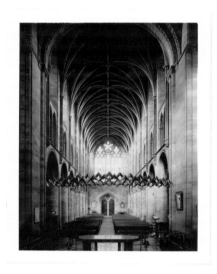

THE CATHEDRAL CHURCH OF THE HOLY SPIRIT
GUILDFORD

THE CATHEDRAL CHURCH OF THE BLESSED
VIRGIN MARY AND ST ETHELBERT
HEREFORD

In 1927 Guildford was one of two bishoprics carved from the massive medieval diocese of Winchester (the other was Portsmouth). A site for the new cathedral was chosen on top of Stag Hill just outside the town, and an open competition was held for the design in 1932. The construction of the church to the winning design by Edward Maufe was begun in 1936 and interrupted by the Second World War. In 1961 the body of the building – which was laid out on a cruciform plan and built of brick – stood complete.

This view down the full length of the building from the nave shows the austere grandeur of the Gothic interior, which is rendered with white plaster and detailed in pale Doulting stone. In the distance is the high altar, with a rose window above and a tall curtain backdrop. The nave elevation comprises very tall arcades supported on boldly faceted shafts. Above these are small clerestory windows, which are concealed in this view by the depth of the walls; along with the tall aisle windows, they suffuse the church with light. The vaults are without decorative ribs, a detail that further emphasizes the simplicity of the building. Each bay, however, is demarcated by an arch that crosses the vault. These arches spring directly out of the wall surface rather than rising from shafts.

A central tower stands over the crossing of the church, its position expressed internally by the deep arches that define a taller and darker bay. Beyond this space is visible the choir with its Gothic-style furnishings, most of which were specially commissioned for the building in the 1950s.

Hereford was established as the diocese of an Anglo-Saxon sub-kingdom called the Magonsaettan in about 680. The church became the burial place of St Ethelbert, king of East Anglia, after his murder by King Offa of Mercia in 794, but it was burned down during an attack by the Welsh in 1055. The new church, begun in the early twelfth century and completed by 1148, substantially survived until 1786, when the collapse of the central tower caused extensive damage to the structure. The architect James Wyatt undertook the initial restoration of the building, but his work was overlaid in the nineteenth century by that of Lewis Cottingham and then George Gilbert Scott.

In this photograph, which shows the nave as viewed from the crossing, all that survives from the twelfth-century church is the nave arcade. The upper parts of the interior are largely the work of Wyatt, who, on the instruction of the dean and chapter, shortened the nave by a bay. John Oldrid Scott (the son of George Gilbert Scott) replaced Wyatt's west front in 1902–1908, creating the large window and double door in the distance. Above the nave altar is a corona designed by the silversmith Simon Beer. It was given to the cathedral in 1992 as a memorial to Bishop John Eastaugh (reigned 1974–90) and incorporates fourteen candles, each one symbolizing a deanery of the diocese.

In the late thirteenth century a bishop of Hereford, Thomas Cantilupe (reigned 1275–82), came to enjoy the popular status of a saint; he was eventually canonized in 1320. The papacy had begun to formalize the canonization process by this time, recording and investigating reported miracles in great detail. From the surviving documentation there emerges a fascinating portrait of thirteenth-century life in the wider region. Cantilupe's tomb – known today as his shrine – survives in the north transept.

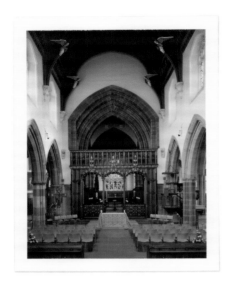

THE CATHEDRAL CHURCH OF ST MARTIN
LEICESTER

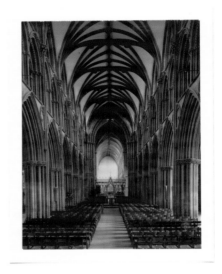

THE CATHEDRAL CHURCH OF THE BLESSED
VIRGIN MARY AND ST CHAD
LICHFIELD

The Roman city of Leicester was possessed of an Anglo-Saxon cathedral from the late seventh century, but it appears to have been destroyed by the Vikings. Then, a millennium later, in 1927, the principal civic church of the town was elevated to cathedral status (Leicester's other important medieval ecclesiastical buildings, including a great abbey and the College of St Mary in the Newarke, had all been demolished at the Reformation). This photograph of the cathedral interior is taken from the nave and looks into the choir beyond the screen.

Cruciform in plan, with two-storey elevations and timber ceilings, the cathedral has a relatively modest architecture that betrays the original parochial status of the building. There are many medieval fragments in the fabric, some dating back to the twelfth century, but in its present form the church is substantially a creation of the nineteenth and twentieth centuries. Among the architects involved in enlarging and rebuilding the structure were G.E. Street, Raphael Brandon and J.L. Pearson.

The church also preserves some interesting furnishings and monuments, such as the seventeenth-century pulpit seen to the right. Most of the choir furnishings, however, were added when the building became a cathedral; they include the canopied bishop's throne and the choir stalls designed by Charles Nicholson. The east window was executed by Christopher Whall in 1920, and in the chancel floor is a memorial slab to Richard III lettered by David Kindersley in 1980. There survives in the south aisle a set of largely eighteenth-century fittings from the former archdeacon's court.

A cathedral on the site of the present building in Lichfield was first consecrated in 700. The see was associated with the powerful kingdom of Mercia and briefly enjoyed the status of an archbishopric, from 787 to 803. It subsequently diminished in importance, and during the eleventh century the see was translated first to Chester and then to Coventry. In the early thirteenth century it became the joint cathedral of a diocese with Coventry, an arrangement that was ended at the Reformation.

This photograph shows the interior of the nave looking towards the choir and the Lady chapel, which opens out beyond the high altar. The present cathedral was created in stages from about 1200. The choir and transepts were completed by about 1240 and the nave by about 1295. The exterior of the cathedral is still dignified by three spires, which were originally completed in the first quarter of the fourteenth century but rebuilt in the 1660s following damage inflicted on the building during three sieges of the city in the Civil War.

The rich surface ornament of the nave elevations is typical of late thirteenth-century English architecture: the design dissolves into a mass of shafts, sculpture and delicate mouldings. In this respect Lichfield contrasts markedly with the relatively restrained and regimented aesthetic of such buildings as Salisbury earlier in the century. The complexity is extended to the vault, each bay of which is divided by ribs into eighteen segments. In one of several borrowings from French architecture, the vault springs from shafts that drop unbroken to the ground.

Lichfield preserves many fine Victorian furnishings, including the iron, brass and copper choir screen seen in the distance. It was designed by George Gilbert Scott and made between 1859 and 1863 by Francis Skidmore of Coventry.

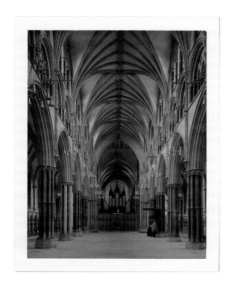

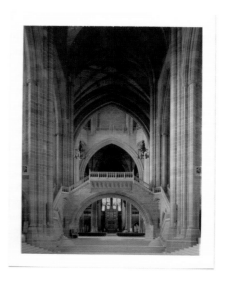

<div style="text-align:center">

THE CATHEDRAL CHURCH OF THE
BLESSED VIRGIN MARY
LINCOLN

THE CATHEDRAL CHURCH OF CHRIST
LIVERPOOL

</div>

Lincoln is one of the most ambitious Gothic cathedrals in Europe. In 1072, immediately after the Roman city of Lincoln was made the new centre of an immense diocese stretching from the Thames to the Humber, work to a large new Romanesque church was begun on a spectacular hilltop site. Most of it, however, was swept away in a century-long rebuilding programme that followed a damaging earthquake in 1185. This view shows the interior of the nave, begun around 1220, with the choir beyond. The two spaces are separated by a stone screen of the 1330s, supporting an organ in a Gothic case made by E.J. Willson in 1826.

The nave is a remarkably delicate interior for its size, and the broad arcade openings allow a clear sight of the aisles beyond the main volume. Its designer was evidently determined to cover the interior with sculpted decoration: the three tiers of the elevation are encased in shafts that lend verticality and linearity to the design. All the shafts and some of the piers of the arcade are carved in dark Purbeck Marble, creating an attractive contrast in colour with the golden stone of the walls.

Meanwhile, multiple ribs were applied across the surface of the vault. The ribs are arranged so as to create the impression of a tunnel of decoration running the length of the nave. This treatment draws the eye along the interior, an effect underlined by the inclusion of a single rib studded with bosses that runs along the apex of the vault. The nave pulpit with its tester or canopy comes from the English church in Rotterdam and was made in 1708.

In 1904 Edward VII laid the foundation stone for the present Anglican cathedral of Liverpool. A cathedral had been first established in the city in 1880 and had occupied a former parish church dedicated to St Peter. The new building was designed in complete contrast to this modest structure: the cathedral today ranks among the largest churches in the world. It was designed by Giles Gilbert Scott, who won a design competition for the project at the age of twenty-two. In his early work at Liverpool he was assisted by the eminent neo-Gothic architect G.F. Bodley. Scott revised the design in the course of the building's protracted construction, and died in 1960, long before the final completion of the nave in 1978.

This view from the nave into the crossing and choir conveys something of the immense size of the building. The impression of scale and verticality is accentuated by the mouldings of the principal elements, which soar upwards from the ground. Visual drama is created by the flights of stairs that connect the nave with the higher floors of the crossing and aisles, as well as by the bridge that spans the interior. Although it is designed in a Gothic idiom, the building does not draw exclusively on the forms of one historical period or even one region. The Lady chapel, for example, borrows ideas from German medieval architecture, while the central volume with its vast explosion of space perhaps finds its closest parallel in Spanish buildings.

Beyond the nave bridge is a huge octagonal crossing. The piers of this support a vast central tower with a peal of thirteen bells, the largest of which weighs 14½ tons. The high altar with its great reredos is in the distance.

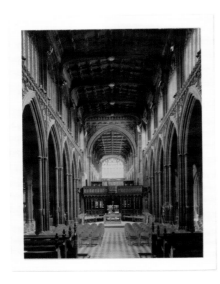

THE CATHEDRAL AND COLLEGIATE CHURCH
OF ST MARY, ST DENYS AND ST GEORGE
MANCHESTER

A new cathedral was established in this medieval collegiate church in 1847. The building reflects in its scale and rich detailing the late medieval prosperity of Manchester, which formed its parish. Although the college was suppressed at the Reformation, its buildings became the home of the celebrated hospital and library founded by the seventeenth-century Lancashire merchant Humphrey Chetham. Since the nineteenth century the medieval fabric of the church has been very heavily restored. The building has also been twice damaged by bombing, once in 1940 and again in 1996 by the IRA.

This photograph shows the nave with the choir beyond. Dividing the two spaces is a screen dating from about 1500, part of an outstanding collection of medieval woodwork in the building. This includes the roofs visible here, densely studded with bosses and decorative ribs, and a fine collection of choir stalls with carved misericords. In the nave, the principal rafters of the roof are supported by the figures of angels holding gilded instruments.

The nave was built in the late fifteenth century but in its present form is a faithful reconstruction dating from 1882–83, overseen by Joseph Crowther. Its rich architectural detailing is contrived to enhance the delicacy of the structure. On the inside face of the arcades, for example, the slenderest of shafts rise from the floor to support the roof. Meanwhile, each arcade pier is notionally treated as a cluster of four thin columns. The upper storey of the nave is opened out to form an almost continuous wall of glass.

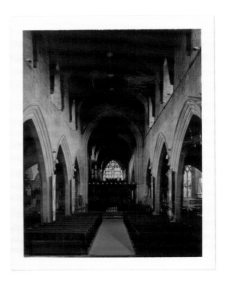

THE CATHEDRAL CHURCH OF ST NICHOLAS
NEWCASTLE

In 1553 an attempt was made to convert the large parish church of Newcastle into a new cathedral. The bid failed with the death of Edward VI in the same year, and it was not until 1882 that this change in status took place. Taken from just inside the west door, this photograph shows the nave and, beyond it, the choir.

The prosperity of Newcastle in the late Middle Ages helped to make St Nicholas perhaps the largest parish church in medieval England. Despite the scale of the building, the nave is only four bays long and was probably completed by about 1350. The design is conventional for a parish church: a two-storey elevation comprising an arcade with a clerestory above. Covering the building is a wooden ceiling (rather than the stone vaults typical of great churches). The roof structure, which is substantially medieval, is ornamented with a series of central bosses. There are no capitals separating the octagonal columns of the nave arcade from the arches they support, one of several striking simplifications of detail apparent in the design.

At the western end of the building, not visible here, a broad arch supports the tower, which is vaulted internally and inset with a large window. Probably completed in the mid-fifteenth century, it has an open spire in the form of a crown and remains a distinctive landmark of the city. Beneath it is an octagonal marble font, with a fine cover of about 1500 in the form of a timber spire. The cathedral preserves a fine collection of monuments from every period.

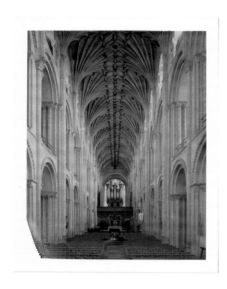

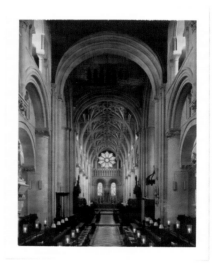

THE CATHEDRAL CHURCH OF THE HOLY
AND UNDIVIDED TRINITY
NORWICH

THE CATHEDRAL CHURCH OF CHRIST
OXFORD

The cathedral of East Anglia was moved from Thetford to Norwich, the economic centre of the diocese, in 1094. Work to the vast Romanesque church that forms the architectural bones of the present cathedral had probably already begun by this date. Its monumental three-storey elevations are still present, as is the central tower over the crossing, the latter a very rare survival from the period. The arrangement of capitals and shafts serves visually to integrate the lower two storeys of the design. This photograph shows the view eastwards along the nave towards the choir.

As originally built, the main volume of the church was covered by a wooden ceiling. Many great Romanesque churches in East Anglia were originally designed in this way, rather than being vaulted in stone. In the late fifteenth century, however, stone vaults were installed throughout the length of the building. In reflection of the English taste for richly detailed architecture, these were covered in a multitude of ribs and studded with carved bosses. The 252 bosses in the nave depict scenes from the Old and New Testaments. The circular opening in the centre of the vault may have been used for suspending devotional images, perhaps the documented figure of an angel with a censer.

The medieval screen separating the nave from the choir was heavily restored by Anthony Salvin in 1833. Above it is an organ rebuilt in a seventeenth-century-style case designed by Stephen Dykes Bower in 1938. The choir itself preserves an important collection of stalls first built in about 1420 but damaged by fire in 1463 and subsequently extended.

This building uniquely combines the role of a cathedral church with that of a university college chapel. It stands on the site of a nunnery founded in the eighth century by St Frideswide, whose relics were displayed in the church during the later Middle Ages; the shrine base for them still survives. In about 1160, following the re-establishment of the nunnery as an Augustinian priory, work to the present cruciform church began. This photograph shows the crossing and the choir as seen from the nave.

The Romanesque elevation was distinctively conceived. It was three storeys high, but the first-floor gallery level was seemingly suspended within the tall arches of the arcades. This boldly conceived structure is ornamented with delicate mouldings and foliage capitals. A timber ceiling originally covered the interior of the church, but in the late fifteenth century a magnificent stone vault with decorative pendants was inserted in the choir. George Gilbert Scott added the rose window at the end of the choir in the 1870s.

In 1524 Cardinal Wolsey decided to found a new college at Oxford, and suppressed the priory to endow it. A section of the priory nave was demolished to make space for a splendid new college quadrangle. The remainder would have been torn down too but for Wolsey's fall from power in 1529. This brought building work to a stop and left the old priory church as the chapel of the new college, Christ Church. In 1546 Henry VIII transferred the bishopric of Oxford to the college, hence the cathedral's combined role today.

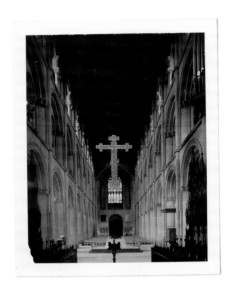

THE CATHEDRAL CHURCH OF ST PETER,
ST PAUL AND ST ANDREW
PETERBOROUGH

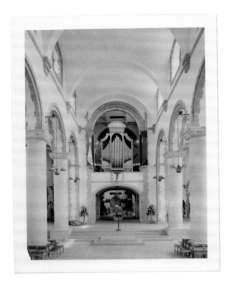

THE CATHEDRAL CHURCH OF
ST THOMAS OF CANTERBURY
PORTSMOUTH

The great Benedictine monastic church of Peterborough was saved from destruction when it was made a cathedral by Henry VIII in 1541. This view from the choir shows the interior of the late twelfth-century nave, which formed part of a church that was first begun in 1118. In the centre of the photograph is the back of the Hanging Cross (1975), designed by George Pace. Just visible to either side are the choir stalls, part of the reorganization of the choir undertaken in the 1890s by J.L. Pearson.

In the form typical of great Romanesque churches, the nave elevations comprise three storeys: a ground-level arcade, a gallery and a clerestory. The detailing of elements is bold and – in a play of forms – the great columns of the main arcade seem to grow through the structure into gallery level. At this upper level the arches are carved with chevron ornament, one of the few touches of Romanesque decoration. A single shaft rising up the face of the elevation from the floor demarcates each bay of the nave. Covering the whole structure is a painted timber ceiling of about 1220, a unique survival on this scale from the period. Within its lozenges are figures including monsters, kings, queens and saints. Happily, it survived a fire in 2001 and has been fully restored.

The roof was completed at the same time as work to the west front of the cathedral, visible at the far end of the photograph. This takes the form of a thin, open-backed tower with three high internal vaults roughly corresponding to the main vessel of the nave and its aisles. The design of the west front imitated the form of a Roman triumphal arch and was inspired by that at Lincoln.

In 1927 the diocese of Portsmouth was carved out of the medieval see of Winchester and the principal church of the town converted into a cathedral. This building was founded as a chapel in the 1180s by the canons of the Augustinian priory of nearby Southwick. A rich merchant, John de Gisors, was the patron of the new building. At the time, Richard I was investing in Portsmouth as a naval base, and in 1194 he conferred on the settlement the status and privileges of a town. To this period belongs the choir of the future cathedral, just visible here through the central arch of the screen. It was not until the 1320s that the chapel became a parish church.

During the Civil Wars of the 1640s the tower of the medieval church was destroyed, having been used as a Royalist lookout. The nave was also seriously damaged. Consequently in 1683, following the Restoration, Charles II approved a plan for the repair of the building. Between 1691 and 1693 the present tower and a nave were erected at a cost of £9000. These also lie beyond the screen.

In 1935 work began to enlarge the building to designs by Charles Nicholson in a German Romanesque style, by extending the church westwards and adding aisles to the nave. This photograph looks along the length of this twentieth-century structure. The low, broad vaults, which spring from the level of the clerestory, are not ornamented with ribs. Work was interrupted by the Second World War and completed by the architect Michael Drury in 1991. The organ on the screen was completed in its present form in 2001; visible here is the west face of the case designed by Didier Grassin and with paintings by Patrick Caulfield.

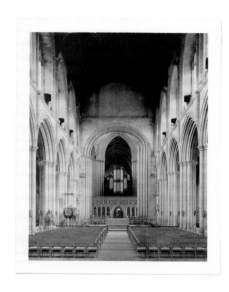

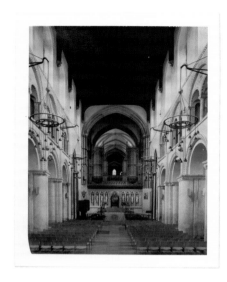

THE CATHEDRAL CHURCH OF
ST PETER AND ST WILFRID
RIPON

THE CATHEDRAL CHURCH OF CHRIST
AND THE BLESSED VIRGIN MARY
ROCHESTER

Ripon, one of three churches in the diocese of York known in the Middle Ages as 'minster' (the others were Beverly and Southwell), became a cathedral in 1836. Looking down the nave, the visitor is presented with a curiously incoherent and asymmetrical interior. This is the product of a long and complex architectural evolution cut short by the Reformation. In origin, Ripon was the site of an Anglo-Saxon monastery founded in the late seventh century by St Wilfrid. From this period there survives beneath the crossing a crypt entered through passages. Designed in imitation of a Roman catacomb, it remains with its relative at Hexham the oldest intact architectural space in England.

Soon after becoming archbishop of York in 1154, Roger of Pont L'Evêque – under whose control Ripon fell – gave the huge sum of £1000 towards its reconstruction. The new church appears to have been the first English essay in the Gothic style, and included such idiosyncratic details as a nave without aisles (a detail copied from York Minster, as it then existed). In this view, the closest arch of the crossing belongs to the twelfth-century building.

Towards the end of the thirteenth century the choir was rebuilt. It is just visible here beyond the crossing and is separated from the nave by an organ and late fifteenth-century screen. In about 1450 the central tower collapsed, precipitating the reconstruction of the crossing and nave. The latter, completed in 1528, was divided by aisles and possessed a two-storey internal elevation in conventional fashion for the period. Concern over the stability of the reconstructed tower led to the erection of a pier to the right of the crossing. The vault is the product of the restoration in 1862–70 by George Gilbert Scott.

Kent is the only county in England with two medieval cathedrals: Canterbury and Rochester. The latter was founded from Canterbury in 604 by the apostle of England, St Augustine, who sent the Roman monk Justin to be the first bishop. As a result, a unique system whereby the archbishop of Canterbury appointed the bishop of Rochester pertained until 1238. Thereafter, in more usual fashion, the monks of the cathedral priory had the right of election.

The vaulted choir of the church is visible in the far distance of this view. It was rebuilt following a fire in 1179 to house the shrines of SS Paulinus and Ithamar, two former bishops. In 1256 the church was additionally provided with a shrine for St William of Perth, a Scots pilgrim murdered in Rochester. Preserved in the choir is a set of stalls dating from the 1220s, the earliest to survive in Britain. The choir was raised above an earlier crypt and is separated from the nave by a medieval stone screen. This was restored in its present form in the nineteenth century with an organ above and niches set with statues.

During the late thirteenth century the reconstruction of the church in a Gothic idiom continued westward through the crossing and transepts as far as the second bay of the nave, but was then abandoned. The completed Gothic bays are visible in the photograph, and in the foreground are the surviving bays of the twelfth-century nave. Despite the relatively small scale of the church, these comprise three storeys in the manner conventional for great Romanesque churches. It is an expression of the relative architectural modesty of Rochester, however, that the nave and its aisles are covered by timber roofs rather than stone vaults.

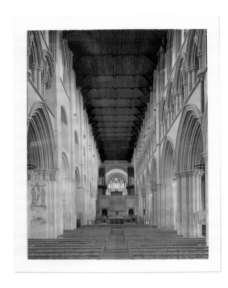

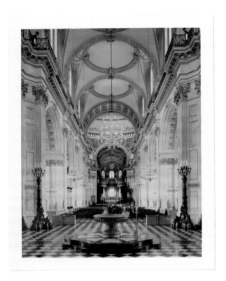

THE CATHEDRAL AND ABBEY CHURCH OF ST ALBAN
ST ALBANS

THE CATHEDRAL CHURCH OF
ST PAUL THE APOSTLE
LONDON

St Alban is claimed as the first English martyr. He was perhaps executed on or near the site of the present abbey church in the third century AD. The great abbey church that contained his shrine was begun in 1077 by Abbot Paul of Caen and made use of materials robbed from the nearby Roman city of Verulamium.

This view down the nave underlines the complex architectural history of this great foundation. In the thirteenth century plans were made to rebuild the eleventh-century abbey nave. These were executed piecemeal and later abandoned. As a result, a section of the original Romanesque nave survives to the left. It faces an elevation of completely different design and one, moreover, interrupted by a buttress halfway along its length. Another later arch is visible on the far left of the image.

With such a confused internal elevation, it was much simpler to cover the interior with a ceiling than to vault it. As a result, a huge timber ceiling extends the full length of the nave to the crossing tower. In the choir beyond, where the shrine of St Alban was located, the building is vaulted in timber. Crossing the church in the middle distance is a fourteenth-century screen with a central altar. More altars stood against the pillars of the Romanesque nave, and many of the pillars bear the remains of medieval devotional paintings. There also survive the traces of medieval architectural paintwork on some of the arches visible in the photograph.

St Albans was made a cathedral church in 1877 and was immediately restored by the lawyer and amateur architect Edmund Beckett (later Lord Grimthorpe). His work was very far-reaching and proved controversial for that reason, although it probably saved the building.

St Paul's expresses on a monumental scale the confidence, interests and power of London in the late seventeenth century as the capital of an emerging imperial nation. It is, nevertheless, a building smaller in every physical dimension than the medieval cathedral it replaced after the Great Fire in 1666. The architect appointed in 1673 to the task of rebuilding the cathedral was Christopher Wren. He initially conceived the building as comprising four short arms of equal length radiating from beneath a central dome. The clergy of St Paul's, however, agitated for a more conventional cross-shaped medieval plan with a long nave and choir intersected by transepts to either side. Wren accommodated their demands but preserved the essential character of his first design by making the dome – a structure without large-scale precedent in England at that time – the visual centrepiece of the building.

While the full size of the dome is not apparent in this view down the nave towards the high altar, the space beneath it reads as a huge, well-lit volume in the centre of the building. By continuing the detailing of the nave arcades across the massive supporting piers of the dome, Wren ensures that the piers become subsumed in the longitudinal design of the building. As originally completed, the interior of the church was fitted out only as the necessities of the Protestant liturgy demanded. The choir was closed off from the rest of the church by a screen and organ, now relocated. Gradually the interior has been enriched: the baldachin over the high altar is an addition of 1949–58 and the mosaics in the choir around it are of the 1890s.

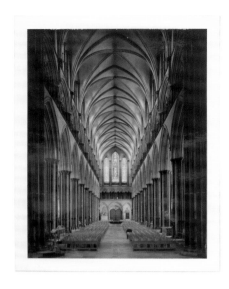

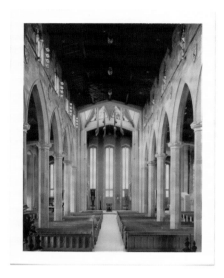

THE CATHEDRAL CHURCH OF THE
BLESSED VIRGIN MARY
SALISBURY

In 1218 the Pope gave permission to transfer the cathedral of Sarum from its position in a royal castle and former Iron Age hill fort to the centre of a new planned city less than two miles away, now known as Salisbury. Work to the new church began in 1220, when the foundations for the entire ground plan were laid out. Building progressed from east to west and was substantially complete within forty years (less its celebrated spire, which is an addition of the early fourteenth century). This view shows the ten bays of the 200-foot-long (61 m) nave as seen from beneath the crossing.

Every feature of the nave is clad in stone shafts. These have the visual effect of fragmenting the design and imbuing it with delicacy. At ground level the main arcades stand on low plinths of stone that separate the nave from its flanking aisles, an unusual detail. This plinth has been used since the Middle Ages as a burial platform and is today lined with funeral monuments. Above the arcades rise the triforium and clerestory levels. The high vaults spring from small clusters of shafts at triforium level. Aside from these shafts, no attempt is made to link the different levels of the building visually. As a result – in characteristic English fashion – the building has a horizontal rather than a vertical accent.

To lend colour and interest to the interior of the nave, the golden Tisbury stone used for the bulk of the building is combined with dark, polished Purbeck Marble. The decorative use of coloured stone was widespread in English fine architecture in the late twelfth and thirteenth centuries. At the far end of the nave is visible the main west door, which is still closed by its original doors. Above it are three tall lancet windows.

THE CATHEDRAL CHURCH OF
ST PETER AND ST PAUL
SHEFFIELD

In 1914 a new cathedral was established at Sheffield in the former parish church of the town. This building already had a confused architectural history, and its medieval fabric had been heavily restored by a sequence of architects beginning in the late eighteenth century. The most important changes were effected by William Flockton in 1880. He created the structure in the foreground of this view, which looks westwards along the nave. Flockton's nave comprises tall octagonal piers with battlemented capitals supporting a clerestory. The austere elevations are ornamented with heraldry. In the manner typical of parish churches, there is no vault but rather a low-pitched timber roof.

After the First World War a scheme was drawn up by Charles Nicholson to incorporate much of the historic fabric of the church into a new design. This plan was altered in 1936 and then abandoned after being only partially completed. In the late 1940s a new nave by George Pace was begun and abandoned. Finally, in 1966 Arthur Bailey executed the western end of the nave, shown in the distance of this view. Above it was created a lantern intended to evoke Christ's crown of thorns.

Among the furnishings of the church visible here is the font, which was made from granite by the local craftsman Charles Green, and incorporates bronze statuary. The exterior of the cathedral reflects a similarly complex history, with a 1960s tower above the south entrance and a fifteenth-century tower with a spire over the crossing.

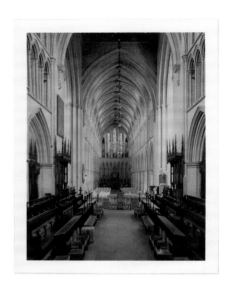

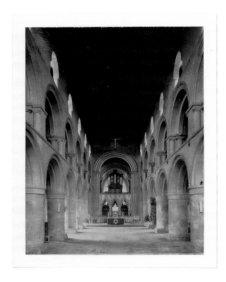

THE CATHEDRAL AND COLLEGIATE CHURCH
OF ST SAVIOUR AND ST MARY OVERIE
SOUTHWARK

THE CATHEDRAL AND PARISH CHURCH
OF THE BLESSED VIRGIN MARY
SOUTHWELL MINSTER

The church of St Mary Overie was an Augustinian priory in the later Middle Ages served by a community of canons. 'Overie' is an epithet referring to its position at the southern end of London Bridge, 'over' the river from the City of London. In 1539 the church was turned to parish use, and it became a cathedral only in 1905. This photograph is taken from the choir and looks westwards through the crossing to the nave beyond. Hanging down in the centre of the picture on an elaborate chain is a fine brass candelabrum; an inscription on it reveals it to have been a gift to the parish in 1680 by a widow, Dorothy Applebye.

Reflected in the fabric of the cathedral is a complex architectural history. The present choir was erected following a fire in 1212, and the crossing and the tower above it were rebuilt in the fourteenth century, reincorporating earlier fabric in the transepts. These medieval elements of the church today bear the stamp of a heavy restoration in the 1830s. While this was under way the medieval nave was first stripped of its medieval timber vault and then demolished.

In 1877 Southwark was removed from the diocese of Winchester, to which it had formerly belonged, and placed within the see of Rochester. The bishop of Rochester, Anthony Thorold, however, wanted the church to serve as a cathedral for London's sprawling southern suburbs. Work to a new nave by the architect Arthur Blomfield began in 1890 with money raised by Thorold. Blomfield's design of an aisled and vaulted structure is thirteenth-century in character to match the surviving choir.

In the Middle Ages Southwell was one in a group of three outstandingly rich churches distinguished by the title of 'minster' in the diocese of York. Along with its counterparts at Beverley and Ripon, it was served in the later Middle Ages by a college of priests. The church survived the Reformation despite the suppression of the college by Henry VIII, but it became a cathedral only in 1884.

Southwell Minster was founded in the mid-tenth century, but the Anglo-Saxon church was rebuilt from the late eleventh century by Archbishop Thomas of York. This is a view down the nave he created. The main arcades are massively conceived and supported on huge drum columns that draw the eye into the side aisles. Above them is a gallery of comparable scale with arches supported on triple shafts. The clerestory at the top of the elevation is much smaller, but the structure is so thick that a passage runs through the depth of the wall between the window on the outside face of the wall and its inner opening. Covering the nave is a wide, open timber ceiling, built following a fire in 1711 to replace a twelfth-century predecessor.

Separating the nave from the choir is a very fine stone screen of about 1320. It stands in the crossing, at the juncture of the choir, transepts and nave. Very unusually, the twelfth-century tower and crossing arches survive; in many cases towers of this date have either collapsed over time or been replaced. Immediately before 1233 Archbishop de Gray decided to rebuild the choir, which is just visible beyond the crossing. It was vaulted in stone.

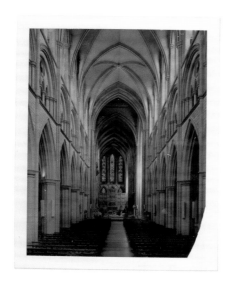

## THE CATHEDRAL CHURCH OF THE
## BLESSED VIRGIN MARY
## TRURO

In 1876 a new diocese was created for Cornwall with a cathedral at Truro. The first bishop, Edward White Benson, was determined to create an appropriately grand building to replace the parish church he had inherited, and in 1877 seven architects were invited to put forward proposals for the new cathedral. On 20 May 1880 the foundation stone of the winning design, by J.L. Pearson, was set in place by the Prince of Wales. The cathedral stood complete thirty years later.

This photograph shows the axial view down the nave and into the choir. As a whole the building measures an impressive 275 feet (84 m) in length. The natural fall of the ground demanded that the choir be built above a crypt, and – as this photograph shows – its alignment is slightly distorted.

The church was laid out on a cruciform plan with a central crossing and spire, and incorporated the sixteenth-century south aisle of the medieval church it replaced. Inspiration for Pearson's design came from the great churches of Normandy. From these buildings he borrowed the idea of linking pairs of nave bays beneath vaults of six parts (rather than the four-part vaults more characteristic of early thirteenth-century English buildings; those are used in the distant choir). He also created an alternating system of full-height shafts that are single or triple in correspondence to the numbers of vault ribs they support.

The rich collection of choir furnishings, many of them designed by Pearson, is visible in the distance. They include the bishop's throne to the left, and the high altar retable or backdrop.

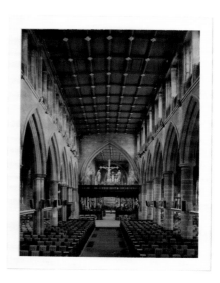

## THE CATHEDRAL CHURCH OF ALL SAINTS
## WAKEFIELD

This large parish church was made a cathedral following the creation of the new diocese of Wakefield in 1888. By this date the medieval fabric of the building had been heavily restored by George Gilbert Scott, whose work to the building between 1858 and 1874 included the dismantling and reconstruction of the great fifteenth-century western spire.

This photograph shows the interior of the nave looking towards the choir and the high altar. At first glance the nave looks regular, with an arcade and clerestory above, but in fact the left-hand arcade is considerably shorter than its counterpart to the right, and incorporates two cylindrical columns (the first and third in the photograph). These belong to a late twelfth-century arcade that was heightened and enlarged with more richly moulded piers in about 1300. The taller right-hand arcade, meanwhile, has alternately round and octagonal columns and probably dates to the thirteenth century. The clerestory and timber roof with its carved bosses date to the late fifteenth century.

The screen dividing the nave and choir is an unusual seventeenth-century survival and is dated 1635. Above it is a rood or Crucifixion group with St John and the Virgin as well as two cherubim, all added by Ninian Comper in 1950. In 1901–1905 the medieval chancel was extended by the architect Frank Pearson to designs first drafted by his father, J.L. Pearson. The stalls are plain and much restored, but their surviving late fifteenth-century features include heraldry and misericords. There is a fine collection of hassocks in the church, many of them made by members of the congregation and local groups.

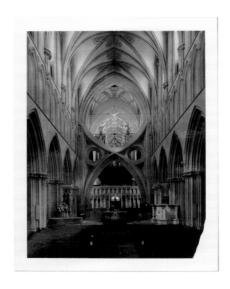

THE CATHEDRAL OF ST ANDREW
WELLS

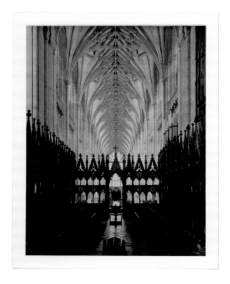

THE CATHEDRAL CHURCH OF THE HOLY TRINITY,
SS PETER AND PAUL AND ST SWITHUN
WINCHESTER

Wells takes its name from the powerful spring that gushes from the ground immediately to the east of the present cathedral. A church was first built here in the early eighth century, but it did not come to enjoy the status of a cathedral until 909. In a complex sequence of events it later lost this status before becoming the cathedral of the diocese of Bath and Wells in 1219. It was in preparation for this dignity that the present church was begun, probably in the 1170s.

This view down the church from the nave to the choir is dominated by a great scissor arch, one of three that brace the crossing piers. These were inserted in the 1330s to support the weight of the central tower. The Crucifixion in the upper part of the scissor arch was sculpted in 1920 by Guglielmo Tosi to a design by Charles Nicholson. Beyond the crossing is the fifteenth-century choir screen, with its organ in a case designed by Alan Rome in the 1970s. Visible above this is the fourteenth-century choir with its spectacular vault.

The present nave was completed in the early thirteenth century. It is vaulted in stone, and the absence of vertical articulation between the bays lends the interior a strong horizontal emphasis. The arcades opening on to the aisles at ground-floor level are thick and richly ornamented, a treatment that contrasts markedly with the much plainer upper storeys of the building. The nave shows close affinities in detail with the nearby cathedral of Salisbury, which was also under construction in the early thirteenth century.

Winchester Cathedral was founded in the mid-seventh century by King Cenwalh of Wessex. The present building, served by a community of Benedictine monks, was begun in 1079 by Bishop Walkelin, beside this early church. Modelled on the plan of Old St Peter's in Rome, it was probably the largest eleventh-century church in Europe north of the Alps. This photograph shows the nave of the church as viewed through the choir, which is laid out beneath the crossing tower of the church.

The original crossing tower collapsed in 1107, one of a catalogue of structural failures caused by erecting the cathedral on unstable and marshy ground. In its present form the Romanesque nave was completely remodelled in the late fourteenth century: its windows were enlarged, an elaborate vault was inserted and a new facing of fashionably detailed masonry applied across its elevations. As a mark of opulence, the new work incorporated a great deal of carved ornament, including a rich array of bosses in the complex vault.

The choir stalls are a remarkable early fourteenth-century survival. A letter of 1308 suggests that a Norfolk carpenter called William of Lyngwood was involved in their production. They incorporate a fine series of carved misericords, and the canopies formerly incorporated carved scenes from the Old and New Testament; they were destroyed in 1642. In the centre foreground is the monument in Purbeck Marble to Bishop Henry of Blois, one of the most celebrated builders of the late twelfth century. Beyond it is a seventeenth-century brass eagle lectern. The choir is separated from the nave by a nineteenth-century screen that imitates the decorative forms of the choir stalls. It was designed by George Gilbert Scott.

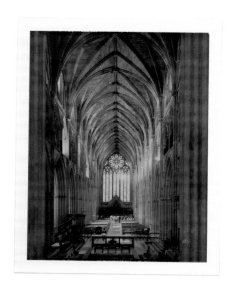

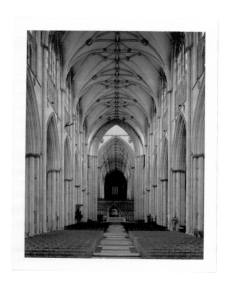

THE CATHEDRAL CHURCH OF CHRIST
AND THE BLESSED VIRGIN MARY
WORCESTER

THE CATHEDRAL AND METROPOLITAN
CHURCH OF ST PETER
YORK MINSTER

The cathedral of Worcester was founded in the 670s by the Greek archbishop of Canterbury, Theodore of Tarsus, to serve the kingdom of the Hwicce. It is not known where the first church stood, but when Bishop Oswald established a monastery on the site of the present building in 983, it soon assumed the role of the cathedral. The Danes sacked that church in 1041, but it was completely rebuilt from 1062 by Bishop Wulfstan (the only Anglo-Saxon bishop to survive the political upheavals of the Norman Conquest).

This photograph shows the nave of the church as viewed from the crossing with the west front in the distance (the main door is partially concealed behind a temporary seating stand). A complex building history is revealed by the architecture. The western end of Wulfstan's eleventh-century nave was remodelled in the late twelfth century. A narrowing of the nave, clearly visible in the distance to the right, demarcates the extent of this structure. Then in the early fourteenth century work began to the complete replacement of Wulfstan's nave, starting on the right with the reconstruction of the north aisle and ending on the left. In reflection of this protracted process of rebuilding both elevations have discernibly different details. Finally, the high vault and the crossing were reconstructed by 1379, and a great western window was completed the following year.

The building was heavily restored in the nineteenth century, first by A.E. Perkins from 1857 and then by George Gilbert Scott from 1864. Scott oversaw the construction of the present west window, which replaced its medieval predecessor, and also the pulpit visible to the left, carved by James Forsyth.

York is the largest surviving cathedral in Britain and is intimately linked to the earliest history of English Christianity. In AD 306 Constantine was proclaimed Roman Emperor by his troops at York, probably in the basilica at the heart of the Roman fort. The remains of the basilica were excavated between 1967 and 1972 beneath the foundations of York Minster. There is reference to an archbishop of York in 314, but Christianity in the city subsequently failed. A new bishop was appointed to the city in 627, but the present church, which dates back to the late eleventh century, may not occupy the site of this early cathedral.

The nave, shown here, was begun in 1291 and was conceived on a vast scale. Its timber vault with a web-like pattern of ribs is supported on shafts that run down the full height of the building to the ground. Above the main arcades is a series of coats of arms celebrating the English nobility. Just above them, at gallery level, are the sculpted figures of knights, and in the stained glass of the high nave windows is a roll call of heraldry representing leading figures in the nobility and baronetage of England. This decoration underlined the character of the nave as a space for the laity and contrasted with the religious imagery of the choir.

The dragon's head projecting into the nave on the left formerly supported a cover for the medieval font. In the distance of this view is the pulpitum screen that separates nave and choir. It includes a spectacular series of fifteenth-century figures of English kings. Beyond is the choir and – just visible above the organ – the outline of the great east window (1407), one of the largest expanses of medieval glass to survive in Britain.

# TECHNICAL NOTE

PETER MARLOW

n my work for this book, the preparation was everything. Although I had decided that the right approach was to photograph with all the lights off, it was very difficult to convince the administrators at each cathedral to let me do it. It required a vast number of telephone calls and follow-up emails for them to give me access before sunrise and to arrange for staff to come in early.

For the set of Royal Mail stamps I photographed in 2007, I used a 6 × 7 Mamiya RZ camera with a 75 mm shift lens to control perspective, with Tri-X Kodak black-and-white film. When the project developed into shooting all forty-two English cathedrals in colour, I decided to increase the film size and quality, switching to a Sinar F1 monorail camera mounted on the largest tripod Manfroto makes. I used a 6-foot stepladder bought from my local hardware shop. Filmstock was Fuji 160 Pro negative colour film, rated at 100 ASA.

Planning notes and map for visits to the
northern cathedrals in summer 2011.

This was more equipment than I could actually carry, and few cathedrals have public parking spaces near the entrance. I tried to get special permission to park outside the west doors, and even invented a very official-looking parking permit to stick on the windscreen, but if that was not possible I would struggle with one of my US-made Porter Cases, which converted into a handy trolley.

It was important for me to keep a sense of the relative size of each nave, since some were enormous and others not. To do this, I used exactly the same elevation on the ladders and tripod, and kept the lens at a constant focal length. After extensive testing at Southwark, I settled on a Sinaron-W 115 mm f6.8 lens, which I used throughout the project. Controlling the vertical perspective was vital, and I used the rising front on the Sinar at its limit to keep all the verticals parallel.

I wanted the whole volume of the space to be in focus, so for most of the images I used a small aperture of between f22 and f32 for maximum depth of field. This required exposures of between one and five minutes. With that length of exposure, reciprocity failure, where the film requires a much longer exposure than is indicated on the light meter, was a big problem. I discovered that Fuji FP 100 Instant film (used for Polaroids) suffered this effect to the same extent as the negative film, and that the aperture setting for a well-exposed Polaroid

Clockwise from top left: Contact notes for the northern cathedrals, July 2011;
Exposure notes for Lichfield, with the black-and-white photograph used by Royal Mail for the first-class stamp, 2007;
Exposure notes for Rochester, April 2010; Exposure notes for Chichester, October 2011.

would be one and a half stops greater than that for the negative film. The exposure meter was essential for monitoring the light levels, which could change quickly with the weather. I would pick a mid-tone point in the cathedral, such as the floor of an aisle, and use it as my reference, although I became increasingly able to use my instinct. By making notes on each exposure I could adjust the aperture as the light changed, keeping the exposure time constant to maintain consistent reciprocity failure.

In most cathedrals I used between six and twelve sheets of film, and about five Polaroids. I edited from contact sheets produced by my laboratory, and made a shortlist, which I scanned using an Imacon 848 scanner. At the end of the project I made a final edit of the forty-two images I wanted to use, and my studio assistant scanned them full frame in 16-bit format using the Imacon. They were then carefully spotted at 66% using Adobe Photoshop 5, and cropped in a consistent 5 × 4 format to remove the film rebates and processing marks.

During the shooting I was very careful to prepare the image by physically moving any distracting objects, such as posters, prayer books, waste bins and welcome desks. Consequently, with the exception of two cathedrals where we cloned out small emergency ceiling lights that could not be turned off, there was no digital manipulation of the images in Photoshop, other than the standard darkroom methods of spotting, colour balancing and tonal adjustment. With no artificial lights this was generally reasonably straightforward, but being so subjective it seemed to take a long time, and was a mentally exhausting process.

We decided to use a PSD format for saving the cleaned-up files, to maintain all these changes in separate layers, so that the process of getting to the final image could be recorded and referred to in case of difficulty achieving a colour proof I was happy with. This made the files enormous, sometimes up to 1.5 gigabytes, and meant I had to increase the RAM in my Intel Mac to 12 gigabytes to handle them. The final files were flattened and saved as 16-bit TIFs, and passed to the printer for proofing with small 8 × 10 Lamda reference prints for colour comparison.

In more than thirty years of photography there have been many times when I was not very well prepared, often lacking a vital piece of equipment. I was determined with this project to have everything I needed to hand, and everything in place in good time so that I could concentrate on experiencing the space and simply 'looking'.

## ACKNOWLEDGEMENTS

Sincere thanks are due to: Jules Wright at my gallery, The Wapping Project, Bankside, who over the years has opened many doors for me; Catherine Brandy from Royal Mail, who by commissioning me in 2007 for her cathedral stamps inadvertently started this project off; Michael Mack, who kindly spent time with me developing the concept; Stuart Smith, who designed the book; Eva Langret at my gallery; all my colleagues at Magnum Photos, particularly our staff in London: Paul Haywood, Fiona Rogers and Sophie Wright; and my assistant, Marcio Suster, whose skill in scanning the negatives was a vital part of the project. Among my Magnum photographer colleagues, I am grateful for the honest and critical eye that Martin Parr, Mark Power, Chris Steele-Perkins and Donovan Wylie cast on the project; early on Martin suggested that I stop shooting in black and white, and continue the project exclusively in colour. This work would not have been possible without the multitude of vergers who arrived very early in the morning to let me into the buildings. However, my greatest gratitude must go to Fiona Naylor, my partner, for her total support, patience and wisdom from the day I set off to shoot the first cathedral, in January 2009, to the day I completed the last, in June 2012.

My photographs are reproduced with the kind permission of the deans and chapters of the cathedral churches of Birmingham, Blackburn, Bradford, Bristol, Bury St Edmunds, Canterbury, Carlisle, Chelmsford, Chester, Chichester, Coventry, Derby, Durham, Ely, Exeter, Gloucester, Guildford, Hereford, Leicester, Lichfield, Lincoln, Liverpool, Manchester, Newcastle, Norwich, Oxford, Peterborough, Portsmouth, Ripon, Rochester, St Albans, St Paul's, Salisbury, Sheffield, Southwark, Southwell, Truro, Wakefield, Wells, Winchester, Worcester and York.

PETER MARLOW is a member of the international photographers' cooperative Magnum Photos. His work has been widely published internationally and is held in major public and private collections. His previous books include *Liverpool: Looking Out to Sea* (1993) and *Concorde: The Last Summer* (2006).

MARTIN BARNES is Senior Curator of Photographs at the Victoria and Albert Museum, London. His previous books include *Illumine: Photographs by Garry Fabian Miller: A Retrospective* (2005), *Twilight: Photography in the Magic Hour* (2006) and *Shadow Catchers: Camera-less Photography* (2010), all published by Merrell.

JOHN GOODALL is Architectural Editor of *Country Life* magazine. He has published and broadcast widely on the subject of English architecture. His most recent book, *The English Castle* (2011), has won several awards.

First published in 2012 by Merrell Publishers, London and New York
This new compact edition first published in 2015

Merrell Publishers Limited
75 Cowcross Street
London EC1M 6EJ

merrellpublishers.com

Illustrations copyright © 2012 Peter Marlow/Magnum Photos, except pp. 7 (© Victoria and Albert Museum, London/F.H. Evans), 8 (© Swiss Foundation of Photography/2012, DACS), 9 (Edwin Smith/RIBA Library Photographs Collection), 10 (AKG-Images/A.F. Kersting)
Texts and layout copyright © 2012 Merrell Publishers Limited

British Library Cataloguing-in-Publication data.
A catalogue record for this book is available from the British Library

ISBN 978-1-8589-4642-9

Produced by Merrell Publishers Limited
Designed by SMITH  Justine Schuster, Ana Rocha (smith-design.com)
Project-managed by Rosanna Lewis

Printed and bound in China

Jacket, front: Chester cathedral; see pp. 35 and 107
Jacket, back: Winchester cathedral; see pp. 97 and 122